IMAGES
of America

SPRINGFIELD
1830–1930

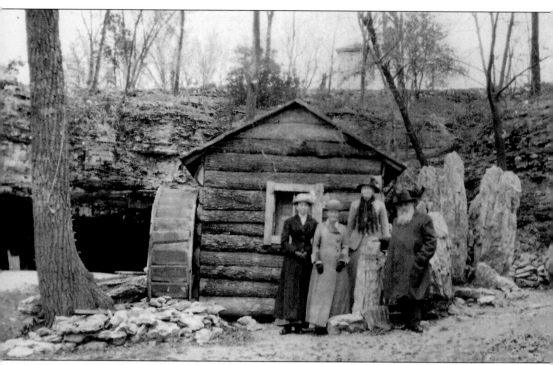

In 1846, John Thomas Giboney and his brother, James, purchased a 40-acre tract for $60. A spring ran from the property's cave with a 6-foot waterfall, providing fresh water and refrigeration. In 1882, James Marshall Doling purchased the land for $2,500, developing it into an amusement center. Doling Park's Giboney Cave was one of the park's attractions during its heyday. (Courtesy of the Springfield–Greene County Library District, the Library Center.)

On the Cover: The Order of United Commercial Travelers (UCT) founded as a secret society in 1888, providing accident insurance for traveling salesmen. Many salesmen traveled for months by horse all day and on trains through the night. It was a hazardous profession with frequent accidents. This 1909 photograph shows the UCT during their company picnic near the entrance to Giboney Cave in Doling Park. (Courtesy of the Springfield–Greene County Library District, the Library Center.)

IMAGES
of America

SPRINGFIELD
1830–1930

Anita L. Roberts

ARCADIA
PUBLISHING

Copyright © 2011 by Anita L. Roberts
ISBN 978-0-7385-8409-6

Published by Arcadia Publishing
Charleston, South Carolina

Printed in the United States of America

Library of Congress Control Number: 2009943879

For all general information, please contact Arcadia Publishing:
Telephone 843-853-2070
Fax 843-853-0044
E-mail sales@arcadiapublishing.com
For customer service and orders:
Toll-Free 1-888-313-2665

Visit us on the Internet at www.arcadiapublishing.com

To my family; without their understanding, patience, and support, this book would not have been completed.

CONTENTS

ACKNOWLEDGMENTS

This book is due to the generosity of the people of Springfield and the many families who shared their photograph albums and histories with me in order to make it a reality.

Thanks to the following individuals and businesses for allowing me access to their photographs: Sue and Roland Alexander, Tommy and Midge Baker, Kristi Bench, Norma and Arlie Bonar, Pat Boren, Betty and Homer Boyd, Allen Casey, Twyla and Dave Choate, Harry Cooper, Patsy Corbett, Leeson Cordoza, Christ Episcopal Church, Barbara and David Dershimer, Pauline Diemer, Alice Dodd, First Baptist Church, Randy Forehand, Sharon and Walt Friedhofen, the Gillioz Theatre, Grace United Methodist Church, Mary Jo Greer, Daniel Hancock, Jerry Haden, Phyllis Holzenberg, Jim Hoover, the Hoover Music Company, Madeline Innes, Rose Jones, Pam Morris Jones, Tom Kerr, William Lee, the Lohmeyer Funeral Home, Sally Lyons McAlear, Dorothy and Bill McCurdy, Gene McKeen, the Mansion at Elfindale, Caroline Post Netzer, David O'Neill, the Ozarks Empire Fair Grounds, Michael Penland, Vince Plaster, Dorothy and John Prugger, Sandy Reese, Allie Roberts, Jean Ann Roberts Coberly, James Roderique, John Ryan, Ron Snow, Sacred Heart Parish, St. John's Episcopal Church, Blake Stafford, Chris Thiessen, Betty Jane Rathbone Turner, Pam Tynes, Washington Avenue Baptist Church, Dorothy Westlake, Wickman's Garden Village, Ann Woolsey, and Karen Morton Yancey.

The people at the following institutions were especially generous with their photograph collections and knowledge: Drury University Archives; Evangel University Archives; Flowers Pentecostal Heritage Center; Grant Beach Park Railroad Museum; Greene County Archives and Record Center (GCA); Missouri State University Special Collections and Archive (MSU); Shrine Mosque of Abou Ben Adhem Temple Museum; and the Springfield–Greene County Library District, the Library Center (TLC).

Special thanks to Nancy Brown Dornan for directing me to Arcadia Publishing and for sharing her grandfather Domino Danzero's photographs.

Publisher John Pearson and editor Anna Wilson at Arcadia Publishing were patient and helpful through this entire process, and I thank them for it.

This book would not have been completed if not for my daughter, Savannah Roberts, who assisted me with pictures, proofreading, and moral support.

INTRODUCTION

Springfield's history began with the formation of the Missouri territory, which was originally part of the Louisiana Purchase of 1803. This new territory drew adventurous men and their families, such as founder John Polk Campbell who came from Tennessee in 1829, and Springfield's first teacher, Joseph Rountree, and his family, who arrived in 1830. The Painters, Alsups, Scroggins, Johnsons, Headlees, Whitlocks, Simms, Bristoes, Robbersons, Rosses, Masseys, Sloans, Leepers, and other founding families closely followed them.

Missouri became a state in 1821, and the local Osage people were removed to the Indian Territory in the Cherokee Nation (now Oklahoma) in 1836 and 1837. John Polk Campbell donated a 50-acre tract to form the city, which incorporated in 1838. That same year, the U.S. government forcibly removed the Cherokee people from their eastern homelands to the Indian Territory across a route dubbed the "Trail of Tears." Part of the route came through the Springfield area via the Old Wire Road, which the Butterfield Overland Stage Company utilized for passenger travel to California by 1858. Two years later, the region's first telegraph line was strung along this road, which earns it the name Telegraph or Wire Road.

During the Civil War, both the Union and Confederate forces utilized the Wire Road. Springfield's approximately 1,500 residents were divided in their loyalties during the War Between the States. In January 1863, Union and Confederate forces clashed in Springfield. The Springfield National Cemetery, where the dead of both the North and the South are buried, was created two years after the war ended.

In the wake of the Civil War, Springfield helped usher in the Wild West era. In July 1865, the public square became the site of the nation's first-recorded shoot-out with a display of incredible marksmanship by "Wild Bill" Hickok for which he became world-renowned. In 1892, the Calaboose became the new police station, replacing a two-room, earthen-floored jail. Springfield's early fire department, the "Pride of the West" Hook and Ladder Company, fought many blazes in a city built primarily of wood.

By 1870, Springfield's population was only 4,500, but with the arrival of the Atlantic and Pacific Railroad Company, larger commercial and manufacturing opportunities were possible. Construction of the line, over 1 mile north of the Public Square, created a new town, North Springfield. The population jumped by 67 percent to 7,500 due to the influx of railroad shop employees. Eventually the Frisco, officially known as the St. Louis–San Francisco Railway Company, merged with all competitive railroad ventures to form one Frisco family with its hub in Springfield.

The Frisco contributed much to the growth of Springfield. It supplied a means to transport the products of the city, aided in the development of industry, and provided employment for the citizens. By 1878, over 150 businesses were in operation, and Springfield became known as the "Queen City of the Ozarks." When the two towns merged in 1887, the population jumped to nearly 20,000.

Wholesale trade accounted for a large percentage of the commercial ventures by the late 1800s. There were cotton and woolen mills, two iron foundries, a carriage factory, grain elevators, tobacco and cigar factories, and the railroad shops. By the beginning of the 20th century, Springfield had nearly 23,000 residents. By 1906, the population swelled to 30,000, of which 3,000 were African American. Springfield was a segregated city, and after the lynching of three black men on the Public Square, the city erupted in violence and bitterness. Afterwards, a mass exodus of hundreds

of African American residents took place as they were forced to live in designated neighborhoods. The affects of segregation are still evident in our neighborhoods today.

The beginnings of today's Springfield City Utilities Company began with the incorporation of Springfield Gas Light Company in 1869 and the Springfield Water Company, which franchised in 1882. The next year, the first waterworks were built at Fulbright Spring, and the Springfield Electric Company formed. In 1893, the gas and electric companies merged to form the Springfield Lighting Company. In 1887, Springfield became one of the first cities in the nation with an electric trolley. Riding the streetcars became a form of entertainment as well as a form of transportation in a growing city; sadly, the last streetcar ran in 1937. In 1930, the first natural gas pipeline came to town, which helped eliminate the black smoke clouds above the city from burning coal.

By 1890, Springfield boasted 36 churches with a dozen missions and chapels representing nearly every denomination. Their members played a significant role in shaping Springfield's educational and health care systems. Organized in 1859, Christ Episcopal Church began using its current sanctuary in 1870, making it the oldest sanctuary still in use. In 1869, the First Congregational Church was founded, and the next year, it helped to locate Drury College in Springfield. In 1880, Drury College (now Drury University) began Stone Chapel, the city's first stone building.

Civic organizations championed community improvement projects. Men joined the Springfield Club, the forerunner of the chamber of commerce, while women became members of the oldest literary club in the state, the Springfield Ladies Saturday Club, which began in 1879. The Parent-Teacher Association began in 1913 and became a driving force in the school district. In 1920, the Shrine Mosque of the Abou Ben Adhem Temple was built, where circuses, dance-a-thons, war bond drives, and concerts took place featuring acts such as John Philip Sousa, Glen Miller, and Elvis Presley. Presidents Harry S. Truman, Franklin D. Roosevelt, John F. Kennedy, Richard M. Nixon, and Ronald Reagan also appeared there.

Missouri's more than 6,000 caves make it second only to Tennessee. The numerous caves and subterranean passages in and around Springfield have their own unique history, whether real or exaggerated. Percy's Cave, now Fantastic Caverns, in northwest Springfield and Crystal Cave northeast of town are worth a visit. The Delaware Indians originally received treaty lands where Sequiota Park and Cave are today. Giboney Cave, in Doling Park, features a 6-foot-tall waterfall and a spring. In 1910, one could enjoy the novelty of an underground boat ride beneath glistening electric lights.

During a meeting in Springfield, in April 1926, U.S. highway officials chose "66" as the number for the 2,400-mile highway from Chicago to California, making Springfield home to the most famous road in America, Route 66. The path of Route 66, "the Mother Road," led straight through the Springfield Public Square. At that time, a Model T cost $400, and gasoline could be bought at one of 13 gas stations on Route 66 for 10¢ per gallon. Motor courts and new hotels were built to accommodate the influx of tourists; including the Kentwood Arms Hotel, which opened on Route 66 in 1926.

The Stock Market Crash of 1929 brought tough times to Springfield, but the people persevered. The community pitched in and got through it together, the same as they did during the 1909 flood or the record-breaking snowstorm of 1912. The images in this book depict the good times as well as the bad times to tell part of the story of Springfield, "Queen City of the Ozarks."

One

OUT OF THE WILDERNESS

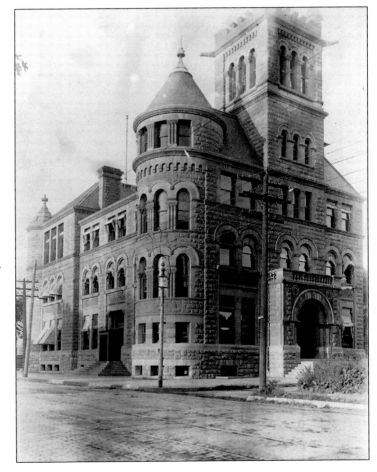

The U.S. Customhouse and Post Office was built on Boonville Avenue and what is now Chestnut Expressway in 1894. The total cost was $153,960.57, with an additional expenditure a year later to install an elevator. Over 5,000 people toured the building during its June premier. This photograph was taken shortly after the grand opening. (Courtesy of TLC.)

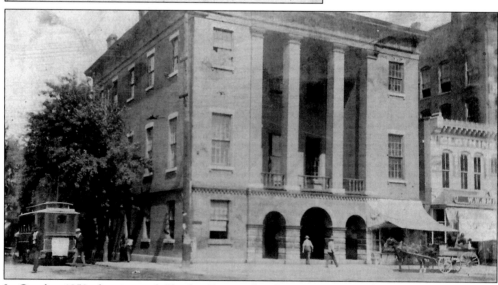

On November 10, 1836, John P. Campbell, Greene County's clerk, signed this document, which appointed Sidney S. Ingram building superintendant. On November 28, Ingram submitted plans for a two-story brick courthouse, which was built for $3,250 in the center of Springfield's Public Square. Unfortunately, in 1861, Peter Ernshaw, a mentally unstable man, accidentally set it on fire while Union troops occupied the city. (Courtesy of Norma and Arlie Bonar.)

In October 1858, the city paid Charles Sheppard and J. B. Kimbrough $3,000 for the northwest corner of the Public Square and College Street for the new courthouse site. William B. Farmer became contractor, with $40,000 for construction costs, which included a jail. In April 1861, many court employees moved into their new offices, which was fortunate, because the old courthouse accidentally burned in October. (Courtesy of Blake Stafford.)

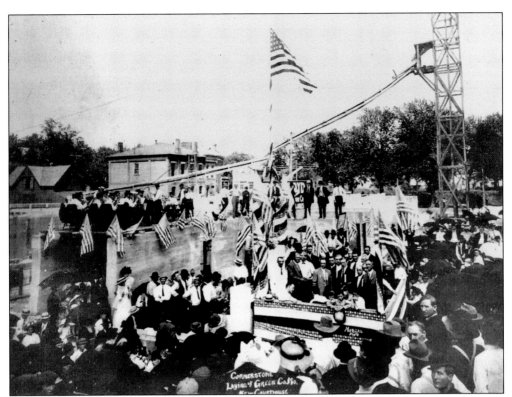

On July 17, 1910, over 5,000 citizens attended the laying of the cornerstone for the new courthouse at Boonville Avenue and Center (now Central) Street. Hobart's Military Band performed, and speeches were given by Mayor Robert E. Lee, and Dr. William Rienhoff, president of the Springfield Club, forerunner of the Springfield Area Chamber of Commerce. (Courtesy of TLC.)

Springfield incorporated on February 18, 1838. In 1855, the Missouri State Legislature granted a city charter allowing the first city elections the next year. In 1856, city clerk Sempronius "Pony" Boyd reported these taxable items: slaves worth $8,950, horses worth $8,260, time pieces worth $1,340, and lots worth $109,535. In 1865, Circuit Judge S. Boyd presided over the trial for "Wild Bill" Hickok's Public Square shoot-out. (Courtesy of GCA.)

In 1907, Charles Brooks, William H. Jezzard, and Ben E. Meyer formed the Springfield Amusement Company and purchased Doling Park for $50,000. They added 19 amusement park rides, including a roller coaster, merry-go-round (now in Henry Ford Museum in Dearborn, Michigan), and a Tilt-a-Whirl powered by spring water from Giboney Cave. In 1912, Jack (left) and Charles Denton enjoyed a 10¢ cave tour, today called the "Underground Classroom." (Courtesy of Patsy Corbett.)

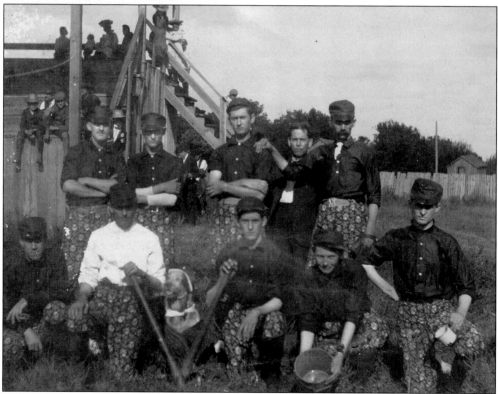

In 1907, Central Park, at Division Street and Boonville Avenue, became White City Amusement Park. The largest U.S. roller skating rink at that time, a vaudeville theater, and a roller coaster were some of the attractions. There was also a baseball field where the Springfield Midgets played. The original wooden bleachers burned after 1911, so in 1920, a 3,000-seat grandstand was erected. (Courtesy of TLC.)

A dog discovered the opening to Percy's Cave in 1862, but it was kept secret until after the Civil War. In 1867, a newspaper ad brought 12 women from the Springfield Athletic Club, armed with ropes, lanterns, and full-length skirts to explore the unknown darkness. Visiting Percy's Cave (now Fantastic Caverns) in 1919 are Richard (right) and Mary O'Neill, nephew and niece of Kewpie Doll creator Rose O'Neill. (Courtesy of David O'Neill.)

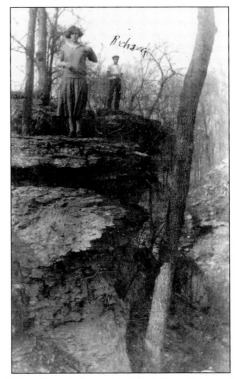

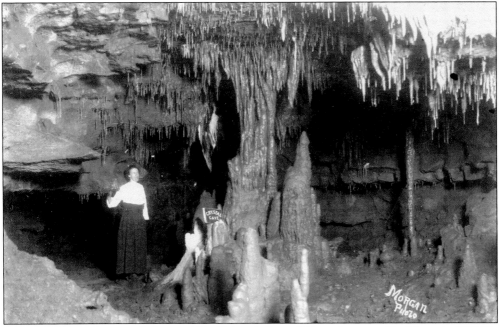

This early 1900s photograph depicts Alfred Mann's Crystal Cave, discovered by Mann in 1893. He developed Missouri's second commercial cave with 10¢-per-person tours. His daughters continued the business after his death. U.S. government geologists considered Crystal Cave so unique they replicated a portion of it at the Smithsonian Institute in Washington D.C. The old Calaboose jail bars cover the first room's entrance. (Courtesy of GCA.)

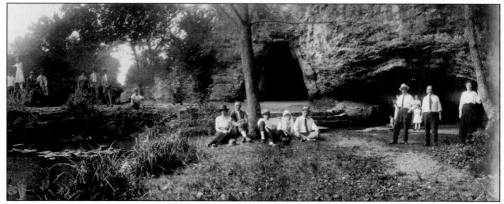

Native American and early white settlers used Sequiota Cave for cold storage. Ten thousand bushels of sweet potatoes were once stored there. In 1913, Harvey E. Peterson paid $10,000 for the Delaware tribe's treaty lands. Originally called Fisher's Cave, it later became Sequiota; which is Indian for "many springs." A Frisco accommodation train ran to Sequiota Park, which the Domino Danzero family visited in 1927. (Courtesy of Nancy Brown Dornan.)

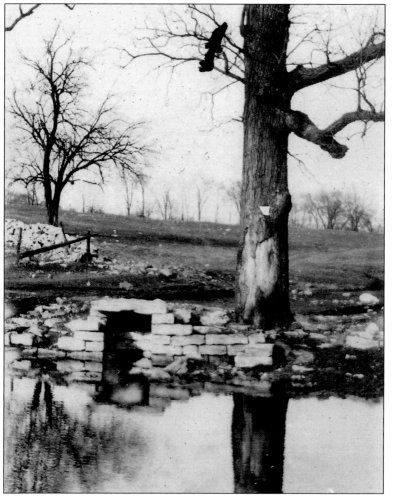

Jones Spring is pictured in the spring of 1916. Henderson Jones, owner of the property in the 1880s and from whom Jones Spring may have derived its name, once established a saloon in a cave near the spring. He and his son, Shelby Jones, sold whiskey to laborers building the Memphis railroad. (Courtesy of Betty Jane Rathbone Turner.)

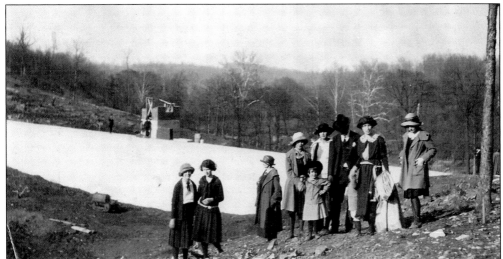

Fulbright Spring was named for early settler William Fulbright who built Greene County's first gristmill. He died in 1844 owning 19 slaves worth $4,500, two clocks and a watch worth $1,500, and 13 mules worth $360. In 1883, the first waterworks were built at Fulbright Spring. Above, in 1923, the Domino Danzero family visits the Fulbright Springs Pumping and Purification House, built in 1910. (Courtesy of Nancy Brown Dornan.)

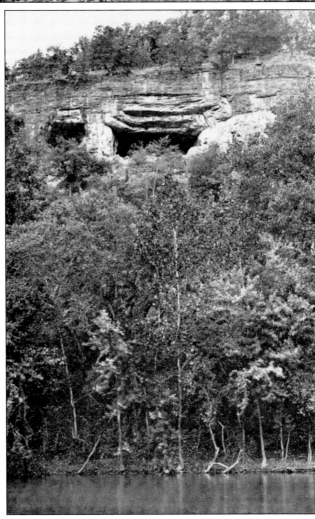

In 1918, the skeleton of a young woman and child were found in Miller's Cave near Springfield. No murder investigation was initiated, because they died of syphilis or tuberculosis during the Mississippian Period, which was between 900 AD and about 1700 AD, according to the archaeologist who discovered them, Gerard Fowke. This photograph was taken in 1910, eight years before Fowke's grisly discovery. (Courtesy of Midge and Tommy Baker.)

TO MECHANICS

AND

Lumber Dealers.

Proposals will be received at this Office until 12 M., Saturday, August 10th, 1867, for the following described Plank and Posts, viz:

2640 feet Plank 12 feet x 8 inches, 1 inch thick.
5940 " " 12 " 6 " "
3300 " " 12 " 5. "
1375 " " 10 " 5 "

660 good Burr or Post Oak Posts, 6x6 at the bottom and 6x2 at the top, to be 6 1-2 feet in length and square at each end.

Separate bids for lumber alone will be considered, as will also bids for labor and other material to enclose in fair workmanlike manner, twenty acres of ground near the City to be used as a Public Cemetery. To insure consideration of bids, reliable reference must be given. For further information apply to the undersigned at old Bank building.

R. B. OWEN,

MAYOR'S OFFICE, SPRINGFIELD, MO., July 30, 1867. Mayor.

In 1867, Greene County's Union men and Springfield's city government paid $218 for 5 acres adjoining Hazelwood Cemetery, which became a national cemetery. Six cannons from Springfield's Civil War forts were placed around the grounds the next year. In 1871, the adjoining 6.3 acres were established as the Confederate cemetery, and on March 3, 1911, it became part of the Springfield National Cemetery. (Courtesy of GCA.)

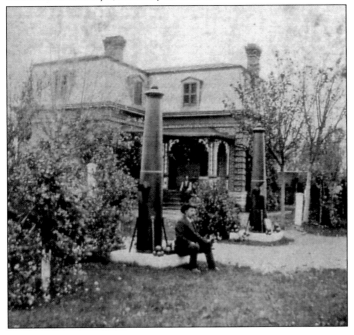

Between 1868 and 1874, $56,776 was spent to relocate nearly 800 Civil War casualties into the National Cemetery (shown in 1870). This included the cost of the ground, the removals, markers, walls, rostrum, lodge, barn, well, flag and staff, trees, and the government agent's wages. The deceased were grouped by state when relocated with the majority of the soldiers coming from Illinois, Iowa, Kansas, and Missouri. (Courtesy of GCA.)

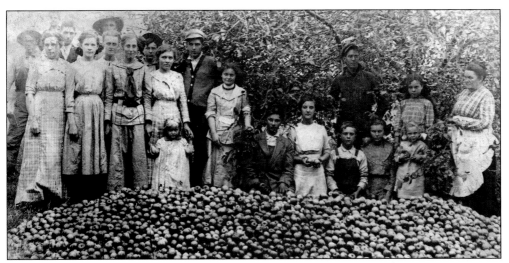

Missouri's commercial fruit growing began in the 1860s. Between 1880 and 1890, Missouri went from 10th to 1st place in the nation, with apples being the main crop. The Ozarks became known as the "Land of the Big Red Apple." Despite a flood in 1886, thousands of barrels of apples were shipped across country. This 1880s photograph shows unidentified apple pickers with their latest crop. (Courtesy of GCA.)

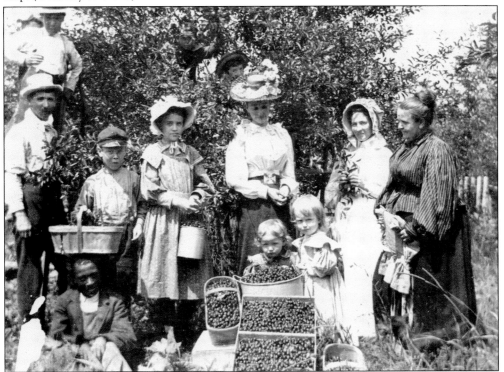

Madison Campbell Vinton, nephew of founder John Polk Campbell, owned Vinton-Baxter Shoe Company on the Public Square from 1880 to 1887. Photographed picking cherries in 1887 are, from left to right (first row), unidentified, Marietta and John Briggs (behind baskets); (second row) Madison Vinton, his son Walter, "Sis" ?, Elizabeth "Ellie" (Madison's wife), Willie ?, and Hannah Farrier; (third row) Jamie, Harry, and William Vinton. (Courtesy of GCA.)

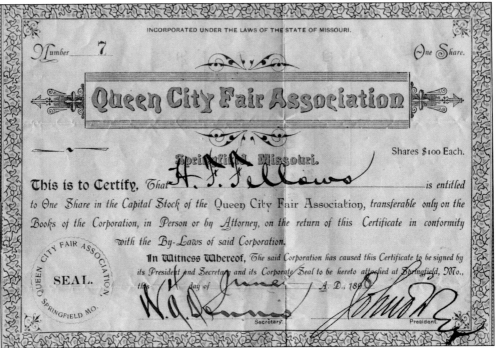

INCORPORATED UNDER THE LAWS OF THE STATE OF MISSOURI.

Number 7

One Share.

Queen City Fair Association

Springfield, Missouri.

Shares $100 Each.

This is to Certify, That *H. F. Fellows* is entitled to One Share in the Capital Stock of the Queen City Fair Association, transferable only on the Books of the Corporation, in Person or by Attorney, on the return of this Certificate in conformity with the By-Laws of said Corporation.

In Witness Whereof, The said Corporation has caused this Certificate to be signed by its President and Secretary and its Corporate Seal to be hereto attached at Springfield, Mo., this ___ day of June A. D., 189_

QUEEN CITY FAIR ASSOCIATION SEAL. SPRINGFIELD MO.

Secretary

President

Col. Homer F. Fellows installed Springfield's first telephone line in his home in 1877 and organized the Queen City Fair Association in 1898. Jesse James's older brother, Frank, served as the official starter of the horse races during its first fair. From September 26 to October 1, 1898, the famous Civil War guerrilla and outlaw drew a crowd to the fairgrounds near modern-day Missouri State University. (Courtesy of Ozarks Empire Fair Grounds.)

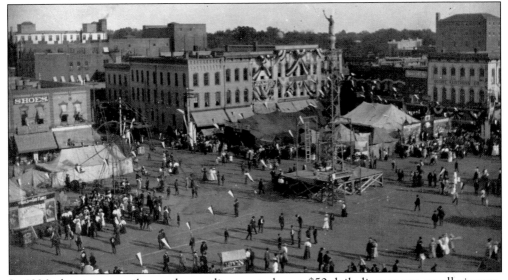

In 1886, the city council passed an ordinance to levy a $50 daily license tax on all circuses, menageries, exhibitions, and concerts. Circuses and menageries were also levied a $50-per-sideshow license tax on every performance. In 1896, the "Girls from Gay Paree" erected their tent on the Public Square's northwest corner. Imagine how many tickets they sold to pay the tax. (Courtesy of Blake Stafford.)

Two

TO PROTECT AND SERVE

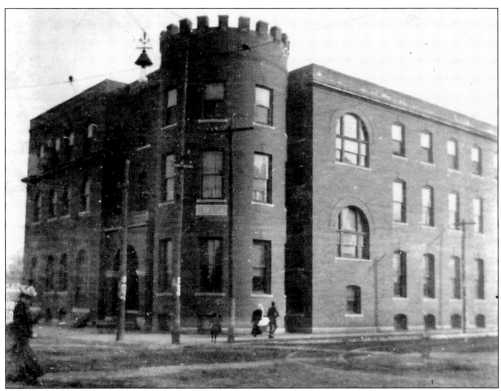

The Young Men's Christian Association (YMCA) began in 1888, using rented space on College Street near Campbell Avenue until a building was built in 1900. Complete with a large gymnasium, 500-seat auditorium, and 27 sleeping rooms, the YMCA Building (shown in 1908) at the southwest corner of St. Louis Street and Jefferson Avenue served the community until 1910, when it was destroyed by fire. (Courtesy of TLC.)

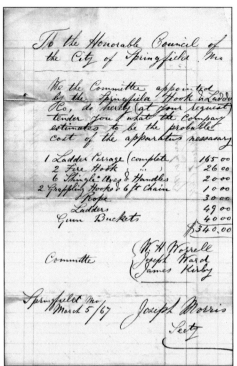

On March 5, 1867, William H. Worrell of the "Pride of the West" Hook and Ladder Fire Company requested $340 to purchase a ladder carriage and other firefighting supplies. By May, the equipment was purchased and a request was submitted for a shelter to protect the new equipment from the elements. In a city constructed entirely of wood, these early firemen fought a losing battle. (Courtesy of GCA.)

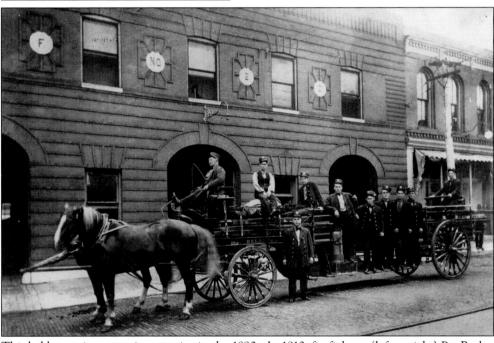

This ladder carriage went into service in the 1890s. In 1912, firefighters (left to right) Pat Burke, Ed Dickenson, Hogey Patterson, Ernest Perryman, ? Waddill, Claude McCurdy, Roy Newton, Al Franklin, Roy Sullens, and R. C. Cloud pose with it. When horse-drawn vehicles were discontinued, they refitted it with a 1917 Ford Model T chassis. The last truck carrying this ladder carriage chassis was a 1936 Diamond T. (Courtesy of Rose Jones.)

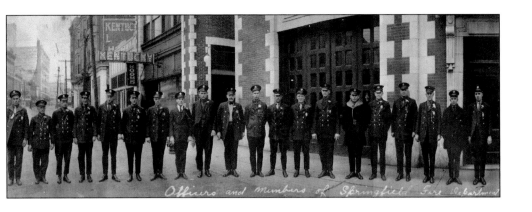

By 1884, Springfield's population, including North Springfield, neared 15,000. The volunteer fire department operated with four hose carts, one hose wagon, and two ladder wagons. In 1898, the fire department at 414 College Street shared its telephone with the Springfield Police Department on the second floor. In 1914, electric alarm boxes were placed around the city. The paid firemen were equipped with two large steam fire engines, two motor-drawn chemical engines, two motor-drawn hose carts, one combination pumper and hose cart, one motorized-aerial truck, one hook and ladder truck, one horse-drawn steamer and four horses, several hose reels, an electrician's wagon, and the chief's car. Property was valued at $110,313, and there were 45 firemen. By 1921, Springfield's population was 39,631. There averaged 70 officers and men in four stations, all appointed by the mayor and the civil service commission. The officers, fire department, and city commissioners are shown in 1921. (Both, courtesy of Jerry Haden.)

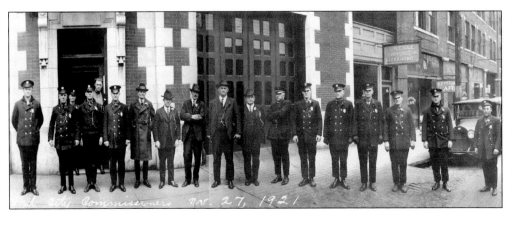

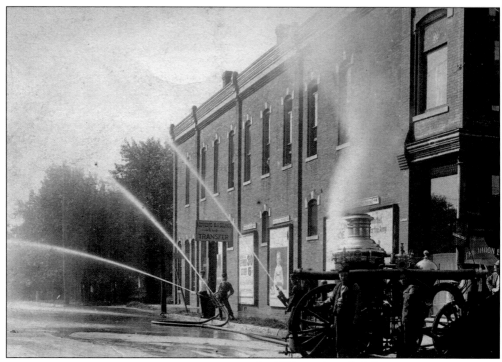

In 1912, unidentified firemen practice using hoses with a steam engine. Locations then included Fire Station No. 1 at College Street with 25 men, Station No. 2 on Commercial Street with 10 men, Station No. 3 on South National Boulevard with 5 men, and Station No. 4 on North National Boulevard with 5 men. The fire chief earned $1,800 per year, and firemen earned $900. (Courtesy of Bill and Dorothy McCurdy.)

In 1888, Springfield police chief Wade Barrett Hindman (shown) conducted an overnight stakeout of a suspect who had eluded arrest by officers Fred J. Palmore and Clay Roberts earlier on Good Children's Lane, which was an area known for criminal activities. A shoot-out occurred resulting in the death of Palmore. In 1889, Hindman received $32.90 for conveying a Springfield pauper to the asylum in Nevada, Missouri. (Courtesy of Sharon and Walt Friedhofen.)

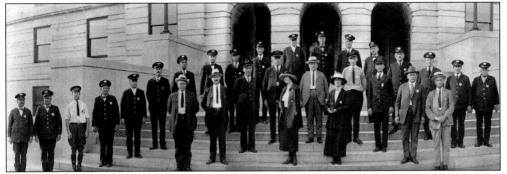

In 1925, the Springfield Police Department posed on the steps of the Greene County Court House on Boonville Avenue and Center (now Central) Street. The next year, there were 2,207 arrests, and $13,125.57 in fees were collected. Margaret M. Hull (right), the first commissioned policewoman, was hired in 1914 to handle female prisoners. (Courtesy of Jerry Haden.)

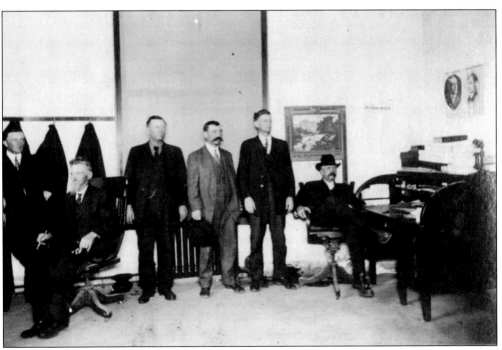

George W. Spencer (seated, right) became a deputy under Sheriff M. O. Milliken in 1902–1903, and then served under Sheriff Rederick Flavius Freeman in 1909 before being elected sheriff himself in November 1912. In 1913, Sheriff Spencer and his unidentified staff are photographed in their new Greene County Court House office at Boonville Avenue and Center (now Central) Street. (Courtesy of Michael Penland.)

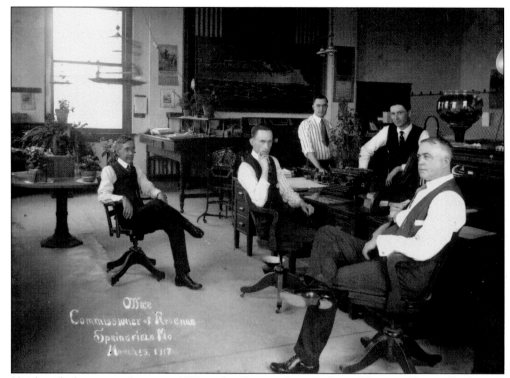

Unidentified men are shown in 1917 in the Greene County Court House at Boonville Avenue and Center (now Central) Street. The commissioner of revenue's office was on the third floor. In the 1930s, it became home to county government agencies such as the farm agent, milk inspector, and health inspector. Springfield's Boy Scout Band also had a third-floor room. (Courtesy of GCA.)

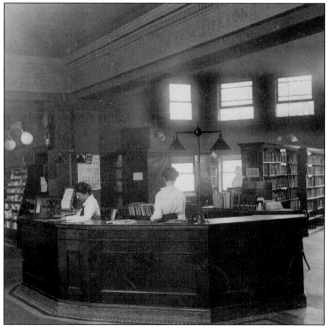

In 1904, construction began on the Carnegie Public Library (now Midtown-Carnegie Branch) at Jefferson Avenue and Center (now Central) Street. It would not have begun without the $50,000 donation from Andrew Carnegie, the "Iron King." It was the first building with a completely tiled roof. Dora A. Wilson was the first librarian. By 1914, Harriet M. Horine was librarian (left), and the shelves held 6,000 volumes by 1916. (Courtesy of TLC.)

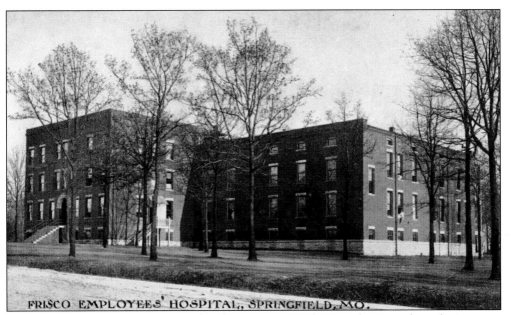

The St. Louis and San Francisco Railroad Company sent their employees and wreck victims to St. John's Hospital until August 1899, when their three-story brick Frisco Hospital opened at Broad Street and Missouri Avenue near the North Frisco Shops. A stable was kept nearby with an ambulance and three horses. In 1921, the Frisco Hospital closed with plans to build an improved hospital, which never materialized. (Courtesy of Caroline Post Netzer.)

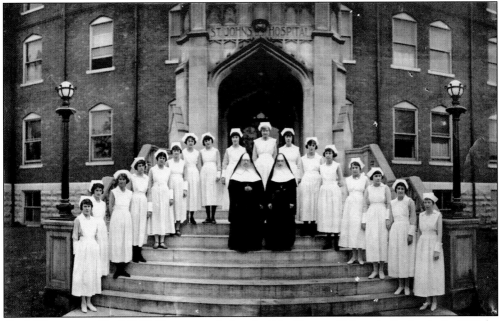

Civil War surgeon Dr. J. E. Tefft was cured of typhoid by Sisters of Mercy in St. Louis. In 1891, he invited the Sisters to run the new St. John's Hospital at Washington Avenue and Chestnut Street. In 1905, Gov. Joseph Polk presided over the cornerstone laying at the North Grant Avenue and Nichols Street location. That year, 125 patients were seen, and in 1923, a $5,000 addition was completed. (Courtesy of Jerry Haden.)

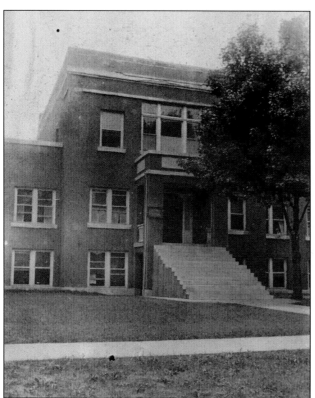

The three-story tile and stucco Southwest Hospital opened May 9, 1914. The following were members of the hospital staff: Dr. H.Arch Lowe, surgeon; Doctors David Ulysses Sherman, Charles H. McHaffie, Green B. Dorrell, Edwin F. James, and Charles Orr, all internal medicine; Dr. Thomas O. Klingner, eye, nose, and throat; and Dr. Murray C. Stone, pathologist and doctors Arthur L. Anderson, C.Wellington Russell, Edward N. Walker, Harve J. Fulbright, and George B. Lemmon. Located on Cherry Street, the hospital was built by J. H. Hinerman, a general contractor who built many residences and business in Springfield. Southwest Hospital could accommodate over 25 patients. (Courtesy of Walter and Sharon Friedhofen.)

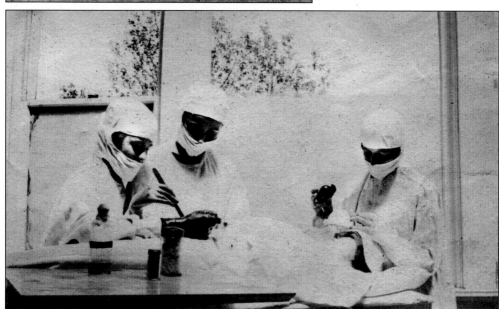

In 1914, surgical nurse Stella DuVall (left) is photographed with surgeon Dr. H. A. Lowe and an unidentified anesthesiologist in the operating room at Southwest Hospital. The operating room was located on the third floor of the hospital. When the hospital opened in 1914, the operating room was advertised to be equipped with all modern appliances in a safe and sanitary environment. (Courtesy of Sharon and Walt Friedhofen.)

The Burge Deaconess Hospital on North Jefferson Avenue opened in March 1908 and is pictured that fall. Grace Methodist-Episcopal Church formed a Hospital Committee who took charge of the care of a hospital room. Former church member, Gladys Ingram, organized the hospital room, which was taken over by the Grace M.E. Church Builder's Class. They supplied linens and new chairs and redecorated the walls several times. (Courtesy of Grace United Methodist Church.)

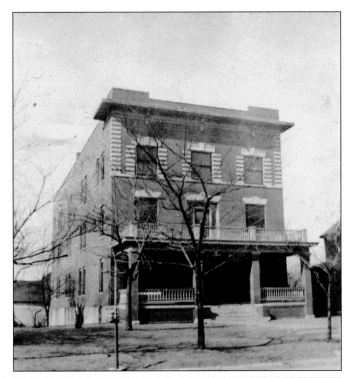

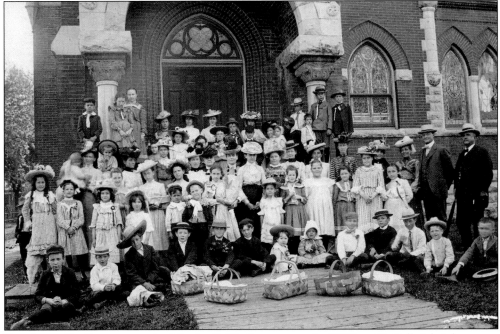

Rev. James H. Slavens preached Springfield's first sermon in William H. Fulbright's home on October 10, 1833. Grace Methodist-Episcopal Church began in 1835, with a small Methodist congregation in a log cabin northeast of the Public Square just two years later. Pastor Harvey Jones (right), who was with Grace M.E. Church from 1899 to 1905, poses with the unidentified Sunday school class before a picnic. (Courtesy of Grace United Methodist Church.)

Calvary Presbyterian Church (shown in 1902) was built in 1879 on property purchased from then–Missouri governor John S. Phelps. By 1930, the congregation had outgrown the St. Louis Street and Benton Avenue building. It joined with First Presbyterian Church (becoming First and Calvary Presbyterian Church), which had built an $185,000 building at Cherry Street and Dollison Avenue just as the stock market crashed, making payments difficult on its own. (Courtesy of GCA.)

Christ Episcopal Church, Springfield's oldest standing church building, is shown in 1914 at the northeast corner of Kimbrough Avenue and Walnut Street before Kimbrough was even a road. The parish organized in 1859 and in 1866 erected a Gothic-style chapel, which it quickly outgrew. By 1871, the new church was consecrated with an altar hauled from St. Louis by oxcart. (Courtesy of Christ Episcopal Church.)

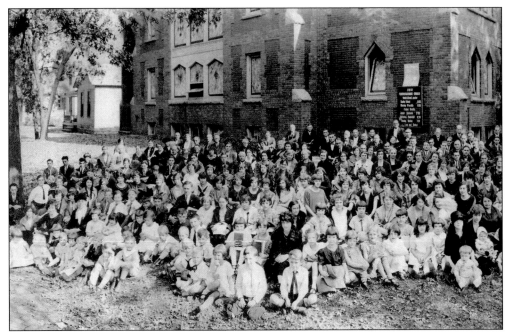

James H. Harwood began First Congregational Church in 1869 as Union Evangelical Church. By 1870, the name changed and a small church was built at Jefferson Avenue and Locust Street. First Congregational Church was part of the association instrumental in bringing Drury College to Springfield. In 1900, two lots were purchased at Benton Avenue and Calhoun Street, and a new church was erected near Drury College (now University). (Courtesy of TLC.)

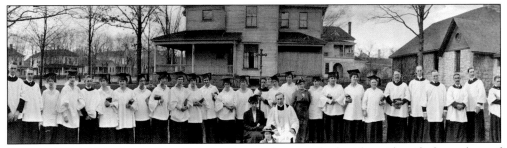

Reverend Weichlein (center) and his family are photographed with unidentified members of the choir, which formed in 1894, at St. John's Episcopal Church at Division Street and Benton Avenue. When the church was completed in 1888, its rose window was the only Gothic-style stained-glass in a Midwest Episcopal church and the only true stained-glass rose window west of the Atlantic seaboard. (Courtesy of St. John's Episcopal Church.)

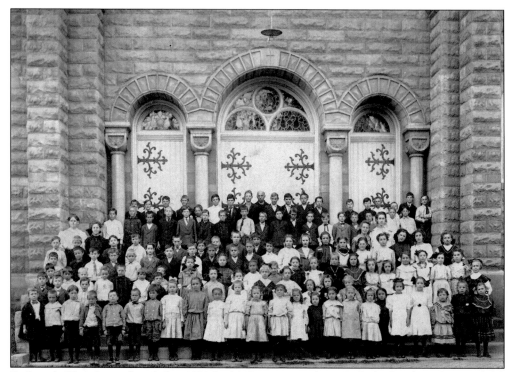

St. Joseph Church was founded in 1892 for 30 German-speaking Catholic families of Springfield. Fr. Maurus Eckstein, O.S.B., (back, center) served as pastor for 30 years. In 1904, ground-breaking began for the 500-seat church at Campbell Avenue and Scott Street. St. Joseph Church cost $22,000 and is probably the first building built in Springfield of concrete blocks, which were made on the spot. (Courtesy of Sally Lyons McAlear.)

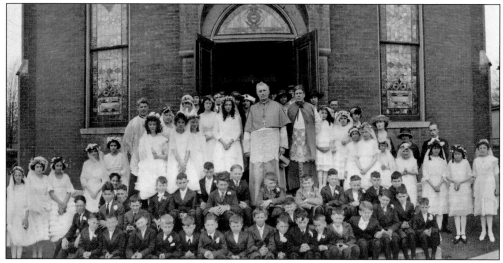

In 1883, a tornado destroyed St. Mary's Church within a year of its being built. By June 1884, it had a new building and name: Sacred Heart Parish. August Lohmeyer, founder of North Springfield's Lohmeyer Funeral Home in 1882, installed the new altars in 1886. Fr. Thomas Brady (center) arrived at Sacred Heart Parish in 1920 and retired in 1956. He performed 649 baptisms and 214 marriages. (Courtesy of Sacred Heart Parish.)

Rev. B. McCord Roberts began First Baptist Church as missionary church in 1852 on Olive Street. This photograph was taken soon after the 1905 wing was added to the South Avenue church, which was built in 1895. During the 1955 demolition of this building, the old parsonage, and the "Baby Building" (the McCrum house used as a nursery), several graves and remains were unearthed that are presumed to be slaves. (Courtesy of First Baptist Church.)

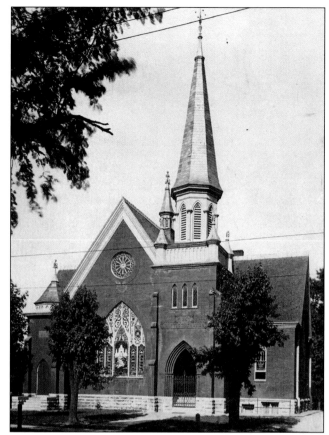

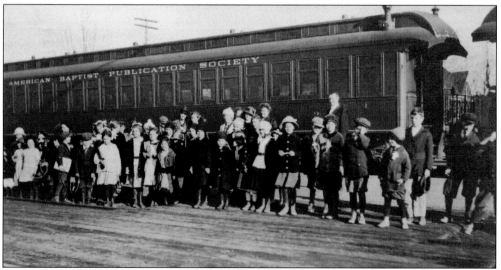

The Chapel Cars of America, 13 churches-on-rails traveled the tracks from 1890 through the 1940s. Catholic Extension Society Cars were *St. Anthony, St. Peter,* and *St. Paul.* The Episcopal Church had three chapel cars. There were seven American Baptist Publication Society cars. In 1916, the *Emmanuel,* now on the National Register of Historic Places, pulled into Springfield, and children pose before the chapel car. (Courtesy of Karen Morton Yancey.)

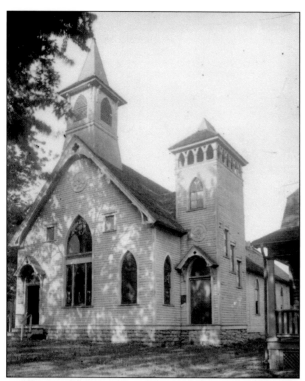

Organized in 1885 by Rev. John H. Thompson, Robberson Avenue Baptist Church became Springfield's second Baptist church. Two years later, construction began on a frame house of worship on the east side of Robberson Avenue fronting Court Street. By 1917, with membership nearing 500, a Ladies Aid Society and a Missionary Organization were formed. The property was valued at $5,500. (Courtesy of GCA.)

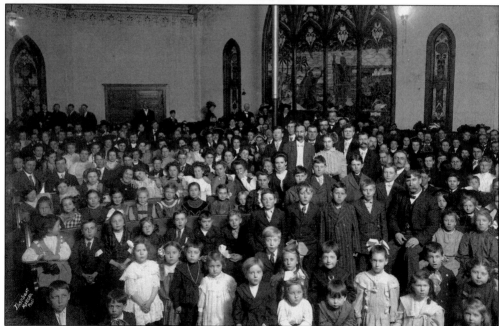

On Christmas Night in 1908, the congregation of the Benton Avenue Methodist-Episcopal Church, at the corner of Benton Avenue and Locust Street, gathered in the sanctuary for this photograph. Ellen A. and George W. Burge were charter church members, and Ellen was a Ladies Aid Society member. In 1907, after George's death, Ellen founded Burge Deaconess Hospital, renamed Lester E. Cox Medical Center in 1968. (Courtesy of Daniel Hancock.)

Central Christian Church, originally called Washington Avenue, is photographed soon after completion in 1889 at the southwest corner of Washington Avenue and Division Street. Matilda Weaver donated $11,000 to build and furnish the church on the condition that no instrumental music would ever be permitted during worship. A split in the church and an anti-organ movement in Springfield resulted that took 12 years to resolve. (Courtesy of GCA.)

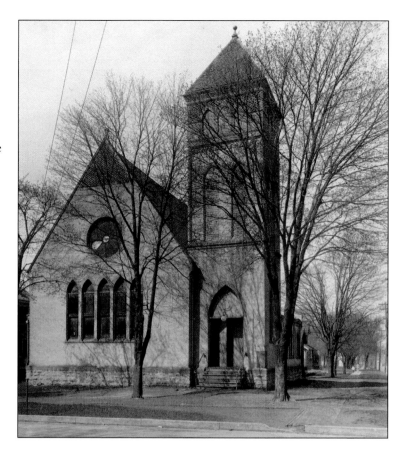

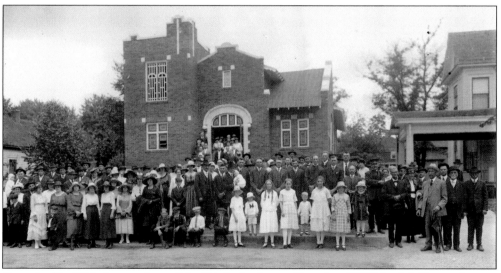

Organized in 1914, the members of the Trinity Lutheran Church at 1008 North Jefferson Avenue pose for a photograph in their Sunday best. A dozen years later, there were 150 members with A. F. Woker as pastor. The house on the south side of the church has since been razed, and the church building has been converted into a private residence. (Courtesy of GCA.)

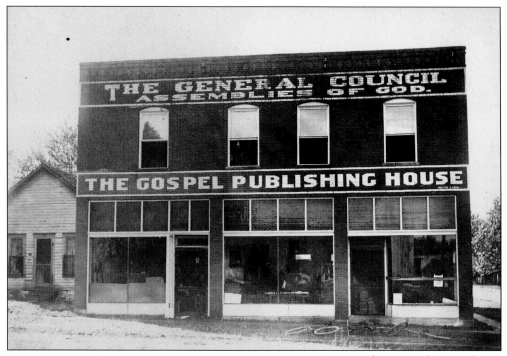

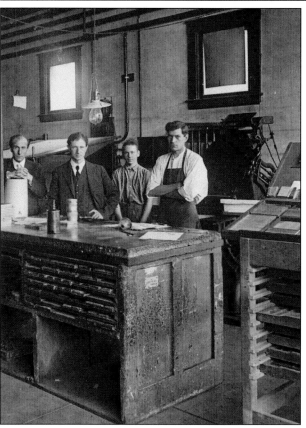

In 1918, the General Council of the Assemblies of God was searching for a location outside St. Louis. General Superintendent Eudorus N. Bell and his staff visited Springfield during their quest and declared the city to be "salubrious . . . out of the dirt and din of a great city." Police officer Harley A. Hinkley, hearing of Bell's hunt, led him to a vacant grocery store and meat market at the corner of Lyon Avenue and Pacific Street. Bell was thrilled with the concrete floors that could support printing equipment, but they were $200 shy of the $3,200 purchase price. Springfield's Commercial Club merchants contributed the $200, ensuring the sale. In 1918, Gospel Publishing House employees (from left to right) J. W. Welch, E. N. Bell, unidentified, and Stanley Fronham pose at 434 Pacific Street after it became the new headquarters. (Both, courtesy of Flowers Pentecostal Heritage Center.)

Three

THERE'S NO PLACE LIKE HOME

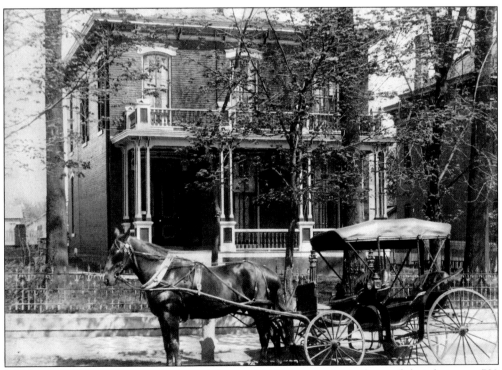

Melchoir and Nancy Jacques Steineger's horse, Old Prince, waits in front of their house at 732 Boonville Avenue in 1890. Steineger learned the saddlery business in St. Louis, Missouri, after emigrating from Switzerland in 1835. He opened Steineger's Saddlery on the Public Square in 1884. During slow periods, Melchoir often stood in the doorway watching ox-drawn wagons gather near the watering trough and public pump. (Courtesy of Pam Tynes.)

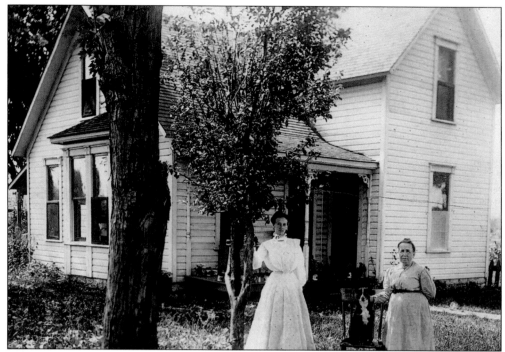

Love Lisenby Emhoff (left) and Nora Emhoff pose on South Fort Street, where Love and her husband, Floyd, began their nursery business, Winter and Summer Garden. In 1922, Floyd incorporated as Emhoff Gardens, selling wholesale from a new greenhouse. Gus and Francis Wickman bought Floyd out in 1946, changing the name to Wickman's Garden Village. Glenn and Donna Kristek bought Wickman's in 1972. (Courtesy of Wickman's Garden Village.)

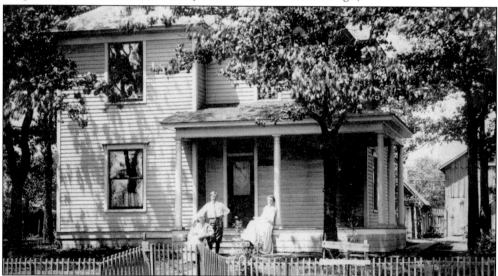

In 1903, Mary (left) and Roy Morton paid $1,700 for their 1073 East Commercial Street home. Madge (right) went to work for the Frisco for $50 per month. She stayed with the railroad for over 43 years. Charles (center) worked for the Barrett Drug Company before opening Morton Brothers Drug Company on Commercial Street with his brother Earl in 1927. (Courtesy of Karen Morton Yancey.)

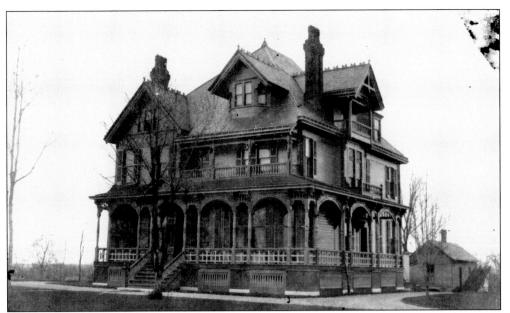

Benjamin Massey, president of the Springfield Furniture Factory, built his home in 1889. Massey was also one of the directors of the Bank of Springfield and an attorney with the firm Massey, McFee, and Phelps until John S. Phelps became governor of Missouri in 1876. In 1923, the Massey House, at the northwest corner of Walnut Street and Kickapoo Avenue, was demolished to become Cordova Court. (Courtesy of Gene McKeen.)

The bedroom of teenager Mary Ruth Cooper is shown in 1910. Mary was born in 1892, the daughter of Grace Keet Smith and George Cooper. George, an English immigrant, began Cooper Brothers Plumbing Company with his brother, Harry, in 1887. The family lived in a gorgeous home on Walnut Street. The photograph was taken a month after Mary's father's untimely death while traveling abroad. (Courtesy of Betty Jane Rathbone Turner.)

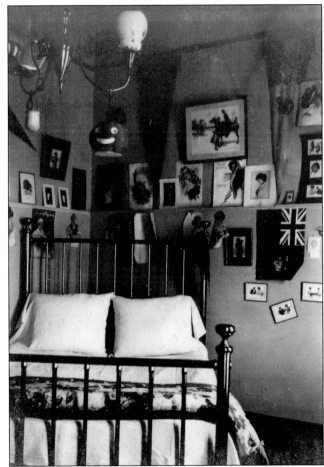

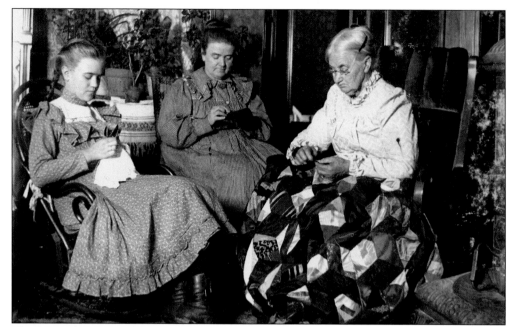

The Panic of 1893 caused financial hardship for many local churches as well as businesses. Mortgage holders pressed for payments and threatened foreclosure. Rev. Melville M. Moore at St. John's Episcopal Church was determined to pay off its $2,300 mortgage. Churchwomen came to the rescue, holding dinners, bazaars, bake sales, and quilting. In 1897, from left to right, unidentified, Hannah Farrier, and "Grandma" Farrier sew together. (Courtesy of GCA.)

Marietta (left) and Johnnie Biggs, descendants of Springfield founder John Polk Campbell, have their photograph snapped in 1887. During the 1880s and 1890s, boys under the age of five wore dresses the same as the girls. A boy's first trousers were knee pants worn over long woolen stockings and high boots. There was also very little difference between girls' and boys' high-topped shoe styles at that time. (Courtesy of GCA.)

38

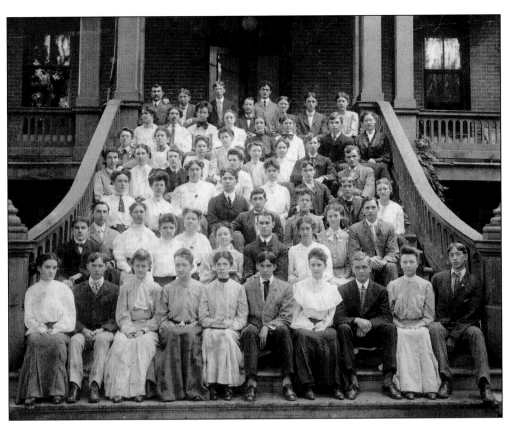

In 1876, Fairbanks Hall at Drury College (now University) was built with a $30,000 gift from Charles Fairbanks as a memorial for his son Walter. Originally the boys' dormitory, it became women's housing in 1878. In 1889, a young lady could live in Fairbanks Hall and receive an education for around $200 per year. The 1890 graduating class is pictured. Fairbanks was demolished in 1978. (Courtesy of Phyllis Holzenberg.)

Malvenia Morrow Steineger (center), the Queen of the Sou'wester, poses with her two unidentified attendants in 1918 in Fairbanks Hall at Drury College (now University). The *Sou'wester* was the Drury College yearbook. Malvenia married Ben McDonald, of the Springfield Grocer Company later that year. Homecoming queens at Drury began in 1929, and the tradition continues today. (Courtesy of Pam Tynes.)

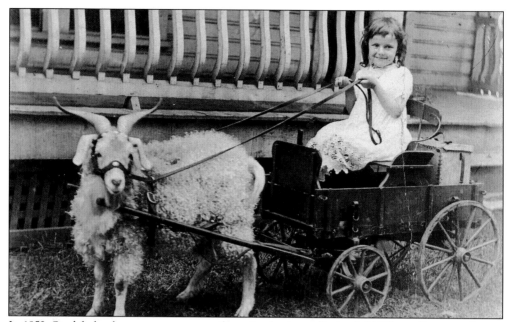

In 1852, Studebaker began a wagon manufacturing business. Springfield Wagon Company began 20 years later. In 1876, Springfield Wagon Company challenged all competitors compare their wagons for a $500 prize. Studebaker accepted the challenge but never showed up. Studebaker began producing electric vehicles in 1902 and "gas buggies" in 1904. In 1913, two-year-old Blanche, daughter of Sarah and Robert Lyons, poses in her Studebaker Wagon. (Courtesy of Sally Lyons McAlear.)

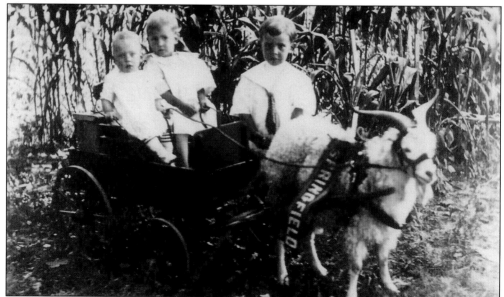

Three unidentified Springfield boys enjoy a ride in a Springfield Wagon Company wagon being pulled by a goat wearing a "Springfield" banner. During the first half of the 20th century, traveling photographers would lead a pony through residential areas, knock on doors, and offer to photograph the resident's children on the pony. This 1920 photograph may have been a similar marketing scheme. (Courtesy of TLC.)

In 1927, three-year-old Arthur Marx poses in his Springfield Wagon Company wagon pulled by a goat. Arthur Jr. grew up to be the third generation to run the Marx Clothing Company on St. Louis Street as it continued in business for over 90 years. In 1976, he sold the St. Louis Street property when the Public Square area became a ghost town. (Courtesy of Madeline Innes.)

Young John Henry George "Jack" Cooper displays his patriotic spirit on the Fourth of July 1906. Jack became the second generation running Harry Cooper Supply Company when his father, Henry "Harry" Cooper Jr., passed away in 1943. Jack's two sons, Jack and Harry, joined the business during the 1950s. In 1993, Jack's son John became vice president, the fourth generation with Harry Cooper Supply. (Courtesy of Harry Cooper.)

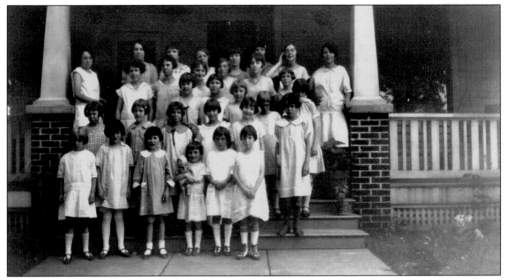

The children at the Centenary Home for Girls are photographed at West Phelps Street in 1926. The home was used for orphans, children of single mothers, and unwed mothers-to-be. The pregnancies were not mentioned. Girls who found themselves in "the family way" could not stay at home. Sponsored by the area Methodist churches, the Centenary Home for Girls provided a safe temporary home for the girls. (Courtesy of Vince Plaster.)

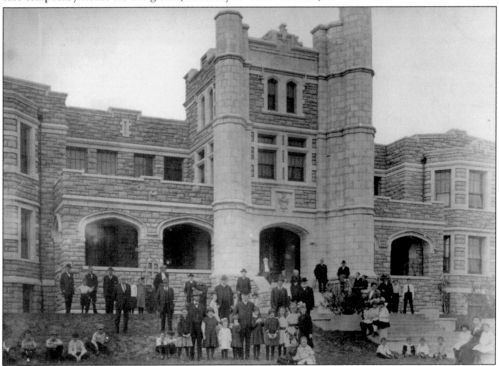

The Knights of Pythias of Missouri began plans for a three-story castle-like structure as a home for orphans and widows of deceased members of their society in 1911. The "Pythian Castle" was dedicated on June 14, 1914, and continued to act in this capacity until 1942, when it became part of O'Reilly Hospital. Unidentified residents are shown in 1922. (Courtesy of TLC.)

In the 1880s, an unidentified family enjoys a meal at its campsite served by their African American servant. The young woman may have lived in the all-black neighborhood of about 30 families on Hampton Avenue just north of Walnut Street. This neighborhood contained simple one-story frame houses belonging to gardeners, clothes washers, and cooks of the wealthy families on Walnut and St. Louis Streets. (Courtesy of TLC.)

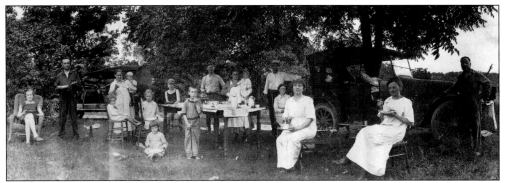

In 1907, Domino Danzero (right), opened Domino's Café on South Street. He founded Domino's Bakery at Pearl and Elm Streets in 1913, acquiring a fleet of horse-drawn delivery wagons. Once, during a delivery, the horses became spooked, overturning the delivery wagon. All 350 hot, juicy pies of every variety were lost. Domino and unidentified family members are photographed during a picnic in the 1920s. (Courtesy of Nancy Brown Dornan.)

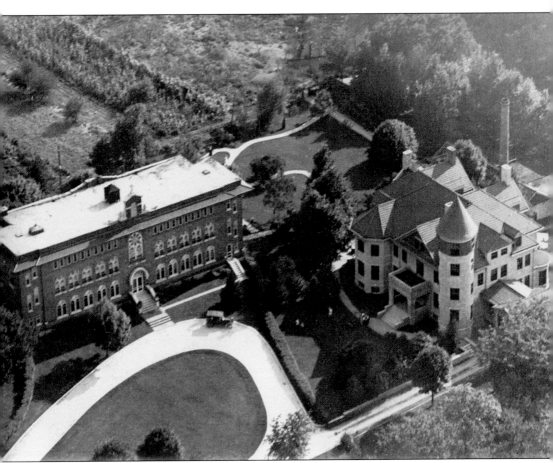

In 1848, Elfindale began with 400 acres purchased for $500. Then, in 1888, one of Greene County's first millionaires, John O'Day, vice president for the St. Louis–San Francisco Railway, purchased it. In 1890, fifty German stonemasons built the 27,000-square-foot mansion with 35 rooms and seven baths. After completion, Clymena Alice O'Day received the property, then known as Park Place, in their divorce. She added a boathouse, summerhouse, and greenhouse and created a lake. Mrs. O'Day claimed the morning mist on the lake looked like tiny elves playing in the dale, hence the name Elf-in-Dale. By 1906, O'Day's funds were depleted, and despite offers up to $259,000, the Sisters of Visitation from St. Louis purchased the mansion for $30,000. They opened the St. d'Chantel Academy for Girls, which operated from 1906 to 1964. The Sisters built the chapel and three-story classroom building. (Courtesy of the Mansion at Elfindale.)

Four

PLANES, TRAINS, AND EVERYTHING IN BETWEEN

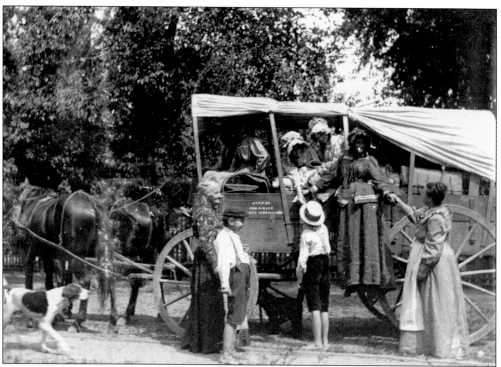

Pioneer travel was slow and dangerous. Wagon tongues and hind axletrees could break or wheels could become stuck in snow or mud too deep to move. An entire day's travel might accomplish only 7 miles or without problems 27 miles. In 1897, "Grandma" Farrier (left, front) and Hannah Williams Farrier (right) bid farewell to unidentified family journeying to Arkansas. (Courtesy of GCA.)

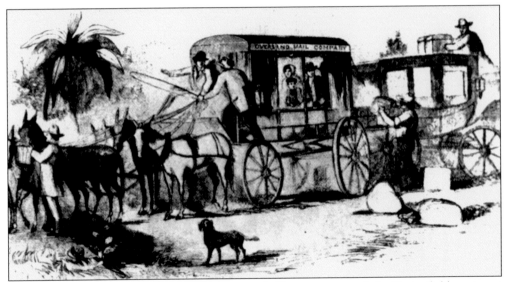

In 1858, the Butterfield Overland Mail Stagecoach Company created the Springfield station at Gen. Nicholas Smith's Tavern on Boonville Avenue. Passengers paid $200 on the St. Louis-to-San Francisco route and they brought their own weapon, blankets, and $4 worth of provisions. This *Frank Leslie's Illustrated Newspaper* drawing shows luggage changing from a stagecoach to a lightweight stagecoach, called a celebrity wagon, in October 1858. (Courtesy of TLC.)

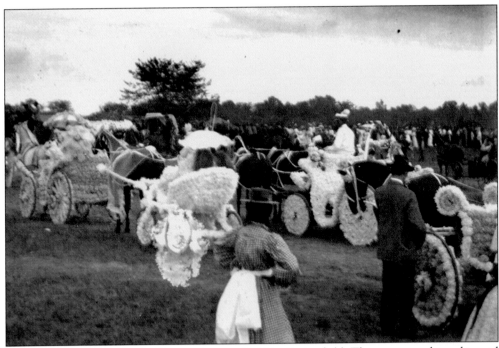

In September 1901, the Elks Convention was held in Springfield. They sponsored a rodeo and roping competition, which Will Rogers entered. He took second place in the steer-roping contest behind his friend Jim Hopkins. Flower-decorated carriages gathered for the grand parade on September 6. Rogers wore a purple shirt and rode his favorite horse, Comanche, in the parade. His future wife, Betty Blake, was in the audience. (Courtesy of GCA.)

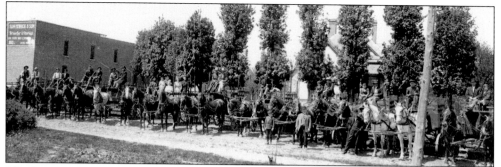

The Sam Herrick and Sons Transfer and Storage Company was located in Patton Alley, where it also sold real estate. Its extensive fleet of wagonettes and heavy-duty wagons are shown in the 1890s. By 1913, the company relocated to 427 College Street, where Sam Herrick Jr. sold automobiles. Within a year, he relocated to the Schneider Building across the street and became a Hudson dealer. (Courtesy of TLC.)

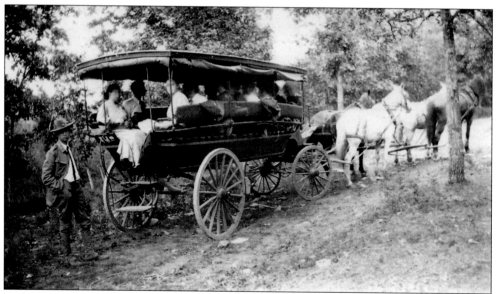

In the late 1890s, the Drury College (now University) botany class rented a wagonette and a team of four horses from Sam Herrick and Sons for an excursion to Knox Cave, which later became Percy's Cave. In 1866, J. G. Knox discovered the cave and explored it for about 1 mile. Until almost 1920, Knox gave tours for a small fee, describing the wonders of the cave. (Courtesy of TLC.)

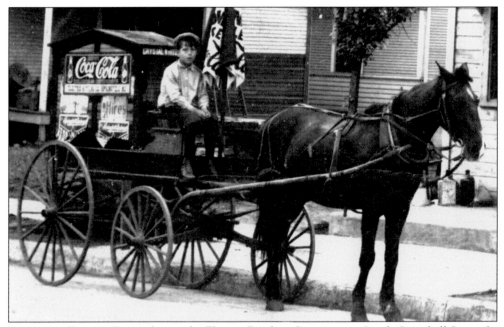

In 1905, William C. Farmer began the Electric Bottling Company on South Campbell Street. In 1910, an unidentified delivery boy poses in an Electric Bottling Company wagon. The principle products sold were Farmer's Root Beer and flavored beverages, seltzer, Coca-Cola, and a specialty drink of Polar distilled water. By 1914, the Electric Bottling Company produced 700 gallons of the distilled water daily. (Courtesy of Ron Snow.)

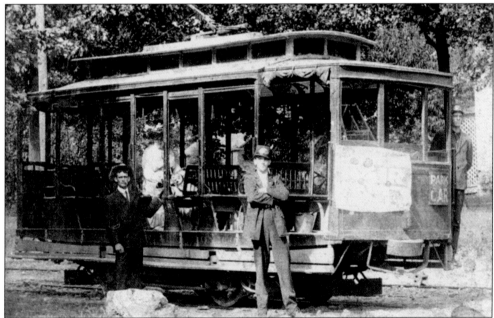

In 1885, Springfield became one of the first cities in the nation to electrify its streetcars. In 1904, a Springfield Railway Company streetcar could take passengers all the way to the Queen City Fair Grounds at Holland Avenue and Grand Street. Springfieldians could be chauffeured around the Speedway on their first automobile ride for only 10¢. (Courtesy of Pam Morris Jones.)

In 1893, the Springfield Gas and Light Company merged with the Springfield Electric Company, becoming the Springfield Lighting Company. It sold in 1902, becoming the Springfield Gas and Electric Company (SG&E). In 1906, the SG&E owners bought the Springfield Traction Company, which had taken over the Springfield Railway Company in 1895. This State Street car has both a conductor and a motorman. (Courtesy of Blake Stafford.)

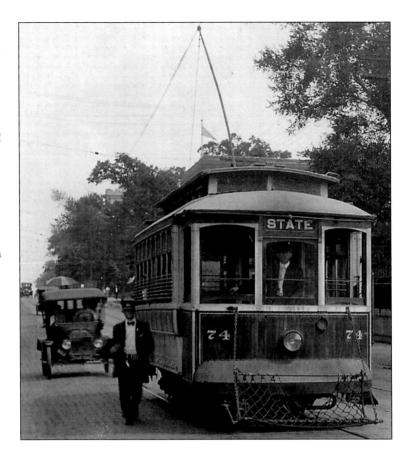

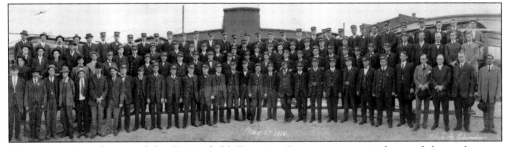

These proud employees of the Springfield Traction Company pose in front of the carbarn at Boonville Avenue and Division Street in 1914. During special events, such as Midget baseball games at White City Park or any Boy Scout Band performances, extra cars were pressed into service. Adults rode for 5¢ and children cost 3¢; children less than six years old rode free. (Courtesy of Jerry Haden.)

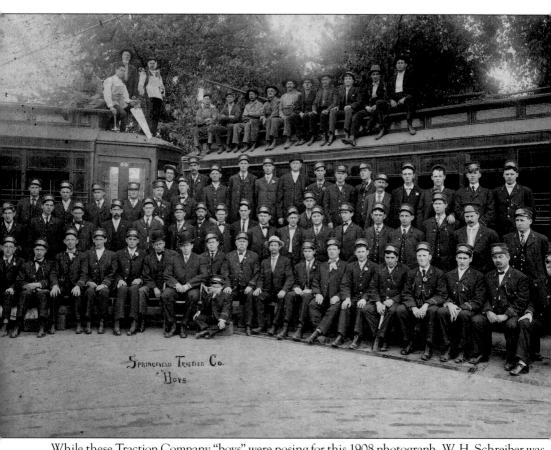

Springfield Traction Co.
"Boys"

While these Traction Company "boys" were posing for this 1908 photograph, W. H. Schreiber was promoting his Springfield, Nixa, and Southern Interurban Railway and Power Company. Schreiber proposed to build an electric streetcar line between Springfield and Nixa. The estimated cost of the 16-mile road was approximately $275,000. The company intended to utilize waterpower from the Finley River to generate motive power. Schreiber was seeking financing and was actively engaged in surveying for the line. By 1910, no financing was secured for the interurban railway, although the surveys were completed. The Traction Company, in the meantime, had big plans for the year. These included constructing a subway under the north side Frisco tracks on Grant Street and laying new steel along the Park and Atlantic Street lines. It also intended to construct a new north-end crosstown line, which would connect Springfield Avenue and the Doling Park car lines. (Courtesy of Vince Plaster.)

The jitney, a wide bus-type automobile that charged only a nickel, became a rival to the electric street trolleys. In 1914, driver Chuck Spencer (above, left) is shown in front of his jitney at Center (now Central) Street and Jefferson Avenue. The jitneys became so prevalent that by 1915, they made up the majority of the registered automobiles in Springfield. The West Walnut Street and New Street line jitney is shown below in 1914 or 1915. In 1916, the Springfield Traction Company appealed to the city council threatening to close some of its lines. This resulted in higher licenses for jitneys in 1917. Problems persisted, and on August 2, 1922, the city council voted the jitneys out of business completely. (Both, courtesy of Jerry Haden.)

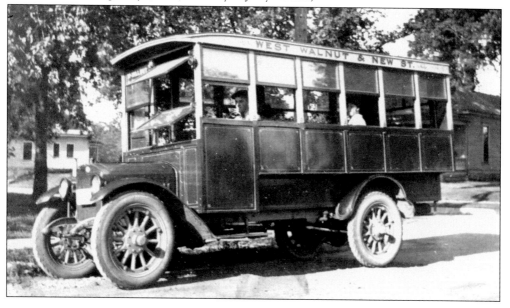

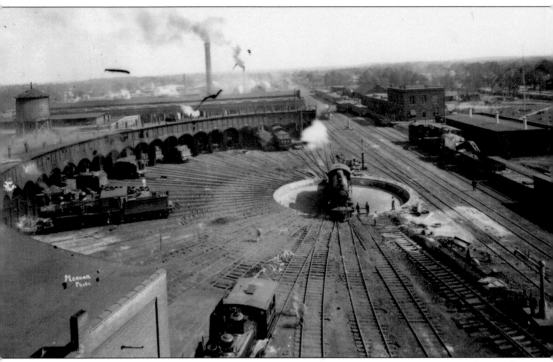

In 1873, the St. Louis and San Francisco Railroad (Frisco) built the Springfield roundhouse, which could accommodate up to 12 engines at one time, on 40 acres in North Springfield at the east end of Commercial Street. The Frisco repair shops, which could handle five engines at a time, were built that same year. The North Frisco Shops became the principal employers of North Springfield, with 173 men turning out over 100 new cars yearly while maintaining 363 miles of track. In 1908, the West Frisco Shops were built on 300 acres 1 mile west of the city limits. The Frisco Office Building, which housed the pay station for several thousand employees, was built at Jefferson Avenue and Olive Street in 1910. By 1924, Springfield was "Frisco Town." It was home to the largest shops in the Frisco's system and the general offices as well as being the terminus of several branch lines. By 1959, most of the more than 40 North Side Shops were razed. (Courtesy of TLC.)

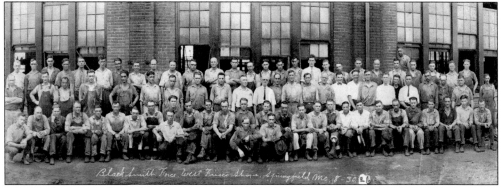

The blacksmith or forge shop at the West Frisco Shops was 102 feet wide by 245 feet long. It contained a 6,000-pound steam hammer for heavy forgings. There were also small steam hammers for light work, as well as milling machines, grinders, and lathes. A "shop mule" or industrial tractor hauled trucks between shops. The Black Smith Force is photographed in 1926. (Courtesy of Grant Beach Park Railroad Museum.)

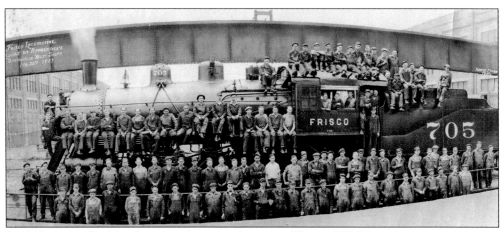

In 1927, one hundred five future mechanics gather around Engine 705. These men were apprentices in all trades—boilermakers, machinists, and blacksmiths—at the West Frisco Shops, which opened in 1909. In 1927, a new coach shop was added for rebuilding and repairing trucks for both steel and wooden cars. The coach shop could hold 20 trucks or 10 cars at a time. (Courtesy of MSU.)

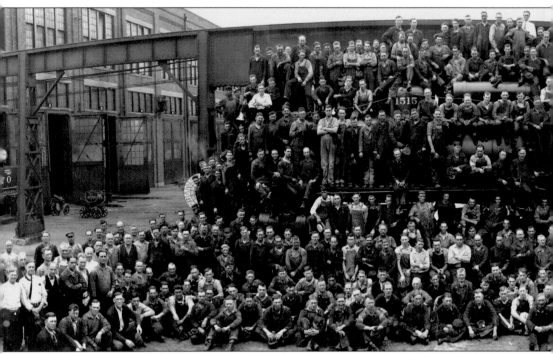

The West Frisco Shops began in 1907 on 320 acres towards which the citizens of Springfield had donated $45,000. The shops opened on July 5, 1909, with 380 men, and the first locomotive was completed on July 17, 1909. The powerhouse delivered AC and DC electricity to the buildings before the city of Springfield had wide spread electricity. The water tower was 150 feet tall, and the smokestack on the powerhouse was 217 feet tall. By 1914, up to 3,000 men were employed, but

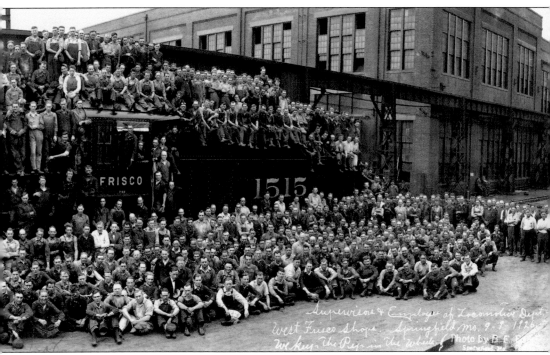

in 1933, only 1,435 had jobs due to the Depression. On September 9, 1926, the supervisors and employees of the Locomotive Department at the West Frisco Shops gathered to be photographed. The department's motto was, "We keep the Pep in the Wheels." (Courtesy of Grant Beach Park Railroad Museum.)

≡ TOMORROW ≡

THE CURTISS BI-PLANES FLY

AT THE COUNTRY CLUB GROUNDS

SOUTHEAST CORNER OF CITY

Take Elm Street Car Line Direct to Entrance Gates

AVOID BRINGING HORSES as they become unmanageable upon seeing the great Aeroplanes in flight, and therefore will be positively excluded from grounds. Autos one dollar extra. (Special arrangements for their convenience.)

Get Your Tickets Down Town in Advance

and avoid possible delay and inconvenience at the Gates. Grand Stand and Reserved Seats 25c to 50c, on sale as follows: Drug Stores--on North Side, Crank's and Reed's; on South Side, Hinton & Hughes, Dalrymple, Hinton Bros., Fink Pharmacy and Owl Drug Store Co., also Heckart's Jewelry Store.

Tents provided to shelter crowd in case of rain.

Rain Check Coupons attached to every ticket.

The Greatest Event in the History of Springfield

DARE YOU MISS IT?

In 1910, Springfield had its first air show. June 11 dawned sunny and fair after two of the coldest and rainiest June weeks in Springfield's history. The traction company laid special tracks to the Springfield Country Club grounds. The first day of the show, 6,000 paying spectators along with many lining the lanes witnessed one of aviation's earliest barnstormers, Charles Forester Willard, 600 feet above the ground. The second day, Willard's engine stopped in mid-flight, and his plane dropped 150 feet to crash in a field. Willard sustained minor injuries and wrecked his machine. He stayed at the Colonial Hotel during the two-week repair time. The *Springfield Daily Leader* reported Willard's prediction, "I think that battles in midair will decide the wars of the future." (Above, courtesy of TLC; below, courtesy of Betty Jane Rathbone Turner.)

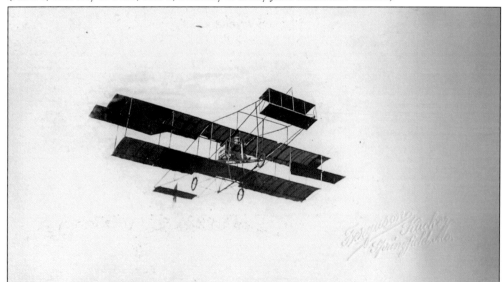

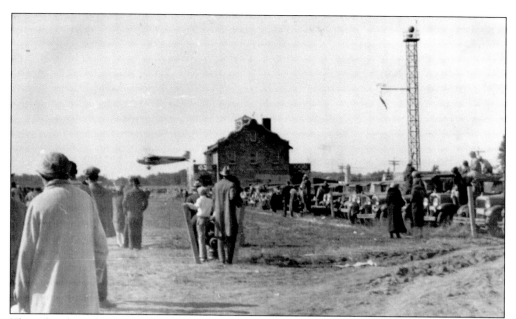

Three local residents opened an airstrip known as McCluer Flying Field in 1925 on J. W. McCluer's farm on East Division Street. It became the first city-owned airport in 1928 and was renamed Springfield Regional Airport. American Airlines, Transcontinental, and Western used the field until the Depression. It continues in use today as the privately operated Downtown Airport. During the late 1920s, a group gathers at the Springfield Regional Airport. (Courtesy of Nancy Brown Dornan.)

Western Union bicycle delivery messenger William Erskine Danforth was 16 in 1916, when he finished the first year of his 60-year career. Erskine wore a topcoat and aviator-style helmet while delivering telegrams, packages, and notes by bicycle. He wore out enough bicycles to stock his own bicycle shop. Over the years, Danforth had several accidents, including a 1931 crash resulting in a skull fracture. (Courtesy of Sue and Roland Alexander.)

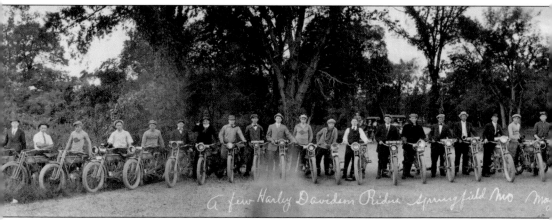

A few Harley Davidson Riders Springfield Mo Mo

Only 12 years after the first Harley-Davidson motorcycle was manufactured, the members of the Harley-Davidson Club of Springfield pose with their own motorcycles for this 1915 photograph. Harley-Davidson Company introduced a three-speed sliding-gear transmission that year. The previous year, the company began manufacturing sidecars, and some of the local riders were among

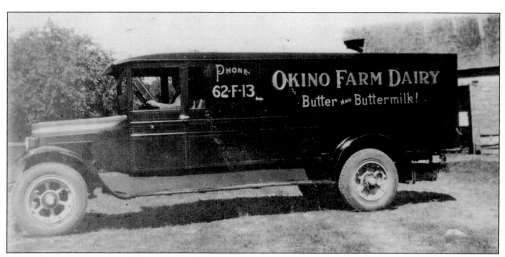

The Okino Farm Dairy delivery truck is photographed around 1928. Jei Okino started the dairy around 1908 on the Danforth Farm just east of Springfield. Home deliveries were originally made by horse and wagon. In the 1950s, the dairy discontinued home delivery when its milk was sold to Hiland Dairy Company, which began in 1938. Okino's closed completely in the mid-1960s. (Courtesy of Ann Woolsey.)

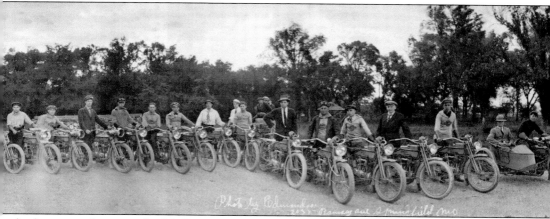

the first to purchase one. Paul B. Duncan's Motorcycle Equipment Company on St. Louis Street was the only motorcycle shop in town at that time. Bert R. Hall was vice president of the company, while Jesse T. Coon acted as secretary and treasurer. Many of the men are pictured wearing Harley-Davidson clothing while others wear suit coats and ties. (Courtesy of Jerry Haden.)

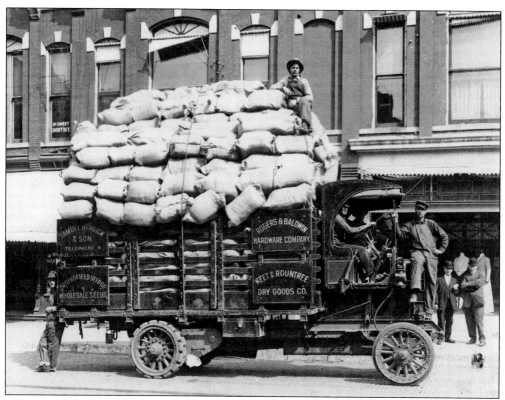

In 1906, the Keet and Rountree Dry Goods Company purchased the Lilburn H. Murray house on West Walnut Street between South Street and Campbell Avenue. The company replaced it with a large brick building. Murray was president of the Western Missouri Railroad Company in the 1880s and owner of the *Springfield Democrat* from 1892 until about 1911. Several unidentified men pose with a Keet and Rountree delivery truck in 1912. (Courtesy of TLC.)

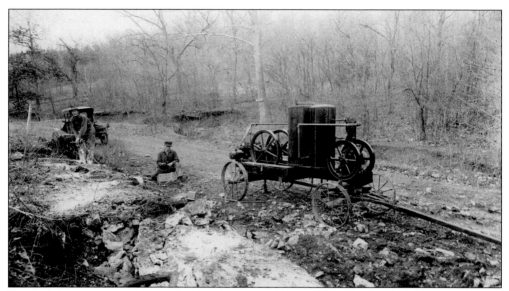

The population increased from 35,000 in 1910 to 39,000 in 1919, requiring the widening of South Campbell Avenue. A Mr. Tinsey (left) and Marion Long used explosives from the Hercules Powder Company, which began in the 1880s, and a Riverside Park air compressor built for the Springfield Special Road District by John L. Schneider, a machinist from the new Frisco West Side Machine Shops. (Courtesy of TLC.)

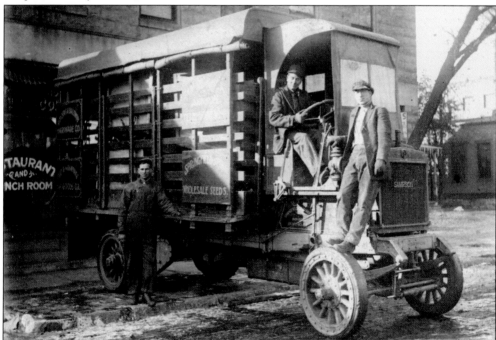

In 1910, three unidentified men pose on their delivery vehicle, which is backed up to a local restaurant and lunchroom. The delivery truck was purchased from Sam Herrick and Sons, later Herrick Motor Company, which was the first automobile dealership in Springfield. The chassis was then customized by the Springfield Manufacturers of Vehicles and sold for just over $400. (Courtesy of TLC.)

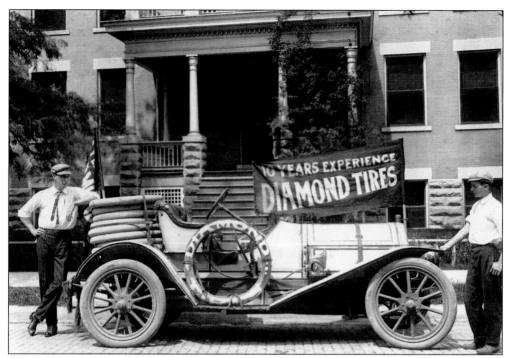

An unidentified man and boy advertise the L. G. Preston Company's 10th anniversary of Diamond Tire Company sales. The Diamond Tire Company was bought out by the B. F. Goodrich Tire Company in 1912. The L. G. Preston Company was at the corner of Pickwick (now McDaniel) Street and Patton Alley. Leslie G. Preston and his employees also painted and repaired carriages as well as automobiles. (Courtesy of TLC.)

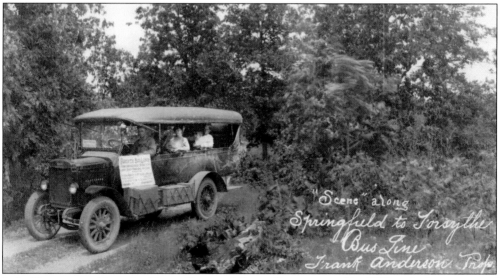

Lake Taneycomo (short for Taney County, Missouri) was created in 1913 with the capture of White River by the newly constructed Power Site Dam near Forsyth. Frank Anderson (driver's seat) began a bus line between Forsyth and Springfield. His headquarters were in the Firestone Agency at McDaniel Street and Jefferson Avenue. Round-trip tickets ran $7, and one-way tickets were $3.75. (Courtesy of TLC.)

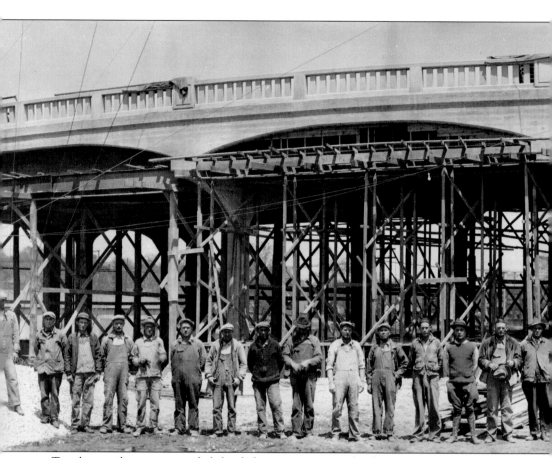

Ten thousand citizens attended the dedication ceremony for the Benton Avenue Viaduct (now the Martin Luther King Bridge) on July 27, 1928. Maurice E. Gillioz and his construction crew, including Guy Hare (5th from left), Henry ? (17th), and Alfred Moret (27th), built the Benton Avenue Viaduct over the Frisco and Missouri Pacific Railroads and the flood-prone Jordan Creek at a cost of $700,000. The Boy Scout Band played, and local officials gave speeches, including Mayor

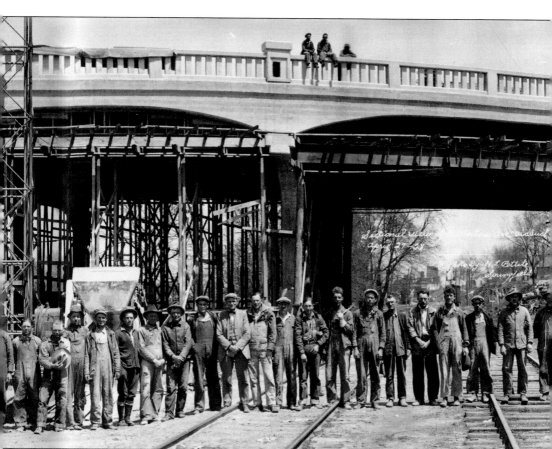

T. H. Gideon; former city attorney Dan Nee; Louis Reps, president of the Associated Realtors; and the commissioner of streets, John P. Ramsey. The Missouri Pacific Railroad's engineer inspected the viaduct and declared that it was so well constructed it would never need replacing. Fifty years later, it was renovated. (Courtesy of Sue and Roland Alexander.)

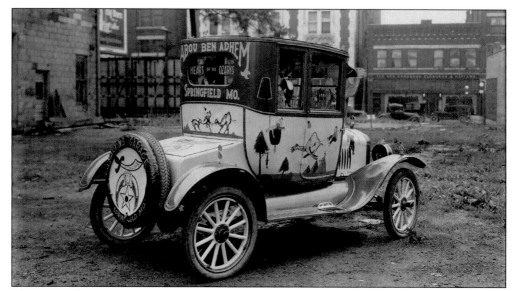

This 1916 advertising automobile was used during parades by the Abou Ben Adhem Temple, Ancient Arabic Order of the Mystic Shrine, which was chartered on July 9, 1903. Initially, it met at the Baldwin Theatre on St. Louis Street. In 1906, together with the Masons, it built a four-story brick building on Walnut Street with voluntary contributions of $1,000. (Courtesy of Shrine Mosque of Abou Ben Adhem Temple.)

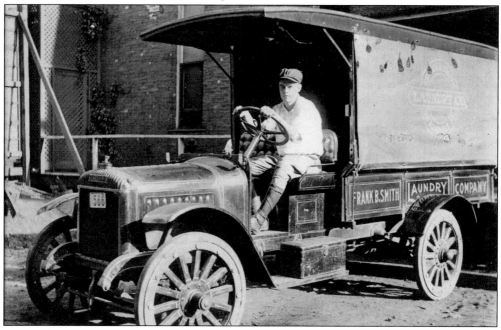

During the 1890s, Frank B. Smith was superintendent for the Springfield Electric Street Railway Company (Springfield Traction Company after 1895). By 1903, he began a family washing service at Boonville Avenue and Phelps Street known as Frank B. Smith Laundry or the "Home of the Purple Box." An unidentified driver is pictured making deliveries in 1917. By 1945, hats were cleaned and blocked for 50¢. For $2.50, the laundry would clean a 9-foot-by-12-foot rug. (Courtesy of GCA.)

Five

STRIKE UP THE BAND

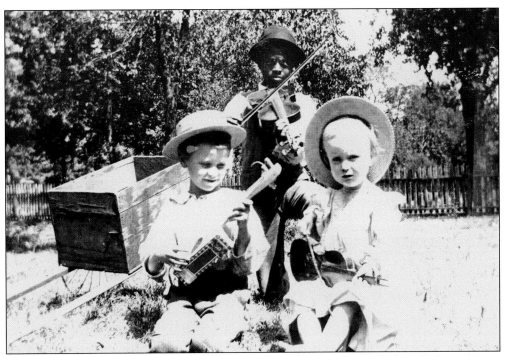

The earliest proof of a cigar box instrument is an etching by French artist Edwin Forbes, a Union army artist. His 1876 sketch depicts a cigar-box fiddle being played at the campsite of two Civil War soldiers. In 1897, Briz ? (back) and Springfield founder John Polk Campbell descendants Dorsey Williams (front, left) and John Williams make their own music. (Courtesy of GCA.)

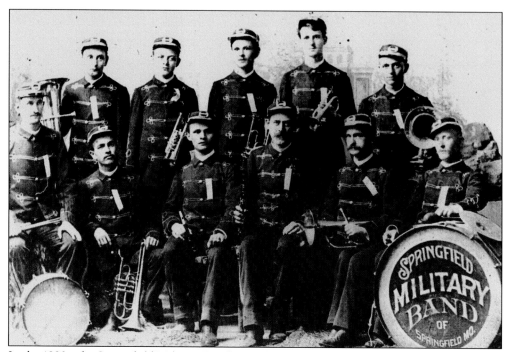

In the 1880s, the Springfield Military Band poses for a photograph. The band, generally referred to as the Hobart's Military Band, performed at the opening of the Crescent Hotel in Eureka Springs, Arkansas, in 1887; the opening of Monett, Missouri, as a Frisco town; and the 1907 Fourth of July celebration at Springfield's Doling Park. Frisco employee John J. Paul was drum major in 1886. (Courtesy of TLC.)

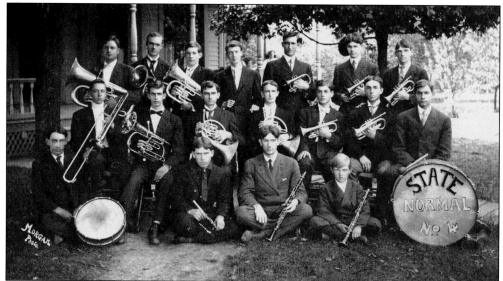

The State Normal School No. 4's first band is photographed on the dormitory lawn at Cherry Street and Pickwick Avenue in 1907. Listed by last name only are, from left to right, (first row) Craig, Dunscomb, Chandler, and Tegarden; (second row) Smith, Cloud, Schneurbush, Segar, Whitlock, McGee, and Newcomb; (third row) Dr. Guy Callaway Sr., Hatch, Tuttle, Reeves, Bell, Barlow, and Rhodes. (Courtesy of MSU.)

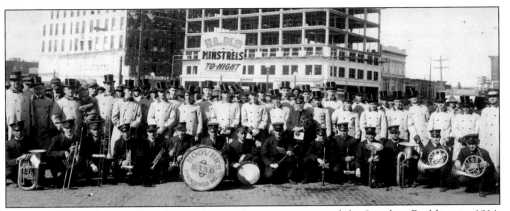

"Little Hoover's Big Band" is shown during the construction of the Landers Building in 1914. Director Herbert Lee Hoover, known as "Little Hoover" due to his short stature, stands to the right of the bass drum in the dark jacket. Begun in 1910, the band marched in parades, performed at local park grand openings, and entertained music lovers across Southwest Missouri for over 30 years. (Courtesy of Jim Hoover.)

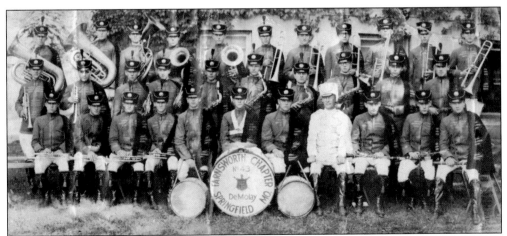

The DeMolay Drum Corps of the Farnsworth Chapter No. 43 of the Order of DeMolay is photographed in 1919, during their first year. R. (Robert) Ritchie Robertson (in white) was their director. DeMolay is an organization dedicated to teaching young men civic awareness and leadership skills in order to lead productive lives. Some famous DeMolay alumni include John Wayne, Walt Disney, and Walter Cronkite. (Courtesy of Jim Hoover.)

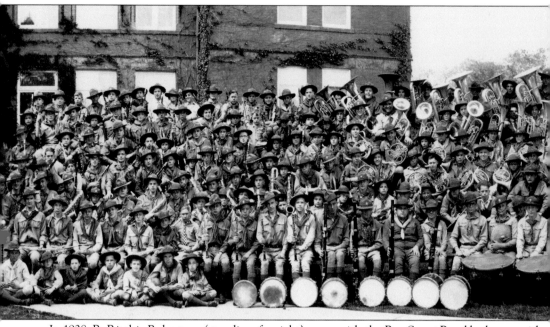

In 1928, R. Ritchie Robertson (standing, far right) poses with the Boy Scout Band he began with Lester Cox and Fred Schweitzer in 1920. During 1928, the Boy Scout Band performed with John Philip Sousa at the Shrine Mosque and serenaded the city hall in St. Louis, receiving the keys to the city. The band assembled before Senior High School (now Central High School), where they often performed. The Frisco Railroad often used the Boy Scout Band for musical entertainment

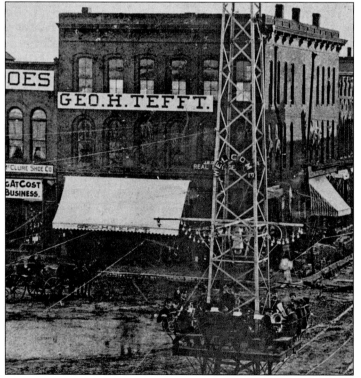

During the 1890s, a brass band's 18 members huddle knee-to-knee around the metal frame of the Gottfried Tower 10 feet above the muddy streets of Springfield's Public Square during the 1890s. The tower was donated by the civic-minded William Gottfried family, owners of Gottfried Furniture and Carpet Company. Springfield's population boom brought a demand for high-quality furnishings, which made Gottfried Furniture one of the most successful businesses in Springfield by the turn of the 20th century. (Courtesy of TLC.)

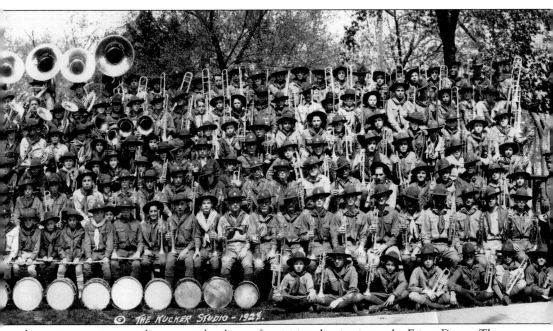

at banquets, reunions, and as a special welcome for visiting dignitaries at the Frisco Depot. They became the official Missouri band when Robertson took 105 boys to the Chicago Century of Progress World's Fair in 1933. The Boy Scout Band was active for almost 30 years, becoming the world's largest Boy Scout Band. (Courtesy of Caroline Post Netzer.)

The Knights Templar band of St. John's Commandery No. 20 performs during a parade around 1915. The Knights Templar organized in Springfield during 1872. St. John's Commandery No. 20 was instituted with Fred King as eminent commander, Washington Galland as generalissimo, and Charles H. Evans as captain general. By 1914, membership reached 319. W. A. Hall and Bert S. Lee both served as state grand commanders. (Courtesy of Nancy Brown Dornan.)

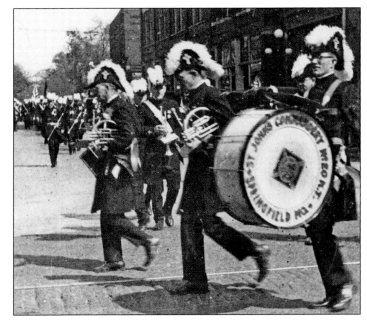

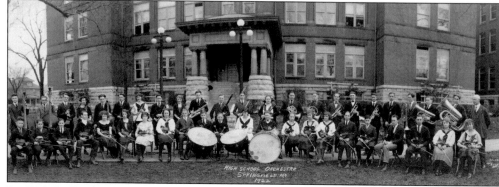

In 1916, R. Ritchie Robertson (standing, right) organized the Senior High School Orchestra and Band, continuing to do so for 23 years. Upon his death, Springfield schools closed at noon, and businesses closed while virtually the entire city honored him. In 1921, one year before this photograph was taken, 64 percent of the high school students were involved in musical organizations due to Robertson's leadership. (Courtesy of Hoover Music Company.)

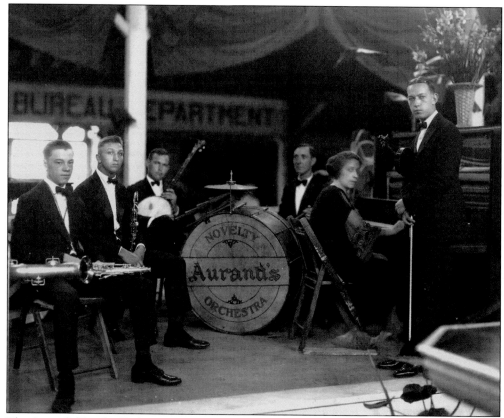

The Aurand's Novelty Orchestra performed in the Springfield area in 1915. Leslie Grant Call (third from left) was the father-in-law of Roberta Ferbrache, who performed with the Springfield Symphony. In 1956, Leslie Call became one of the founding members of the Southwest Missouri Amateur Radio Club of Springfield for ham radio enthusiasts. (Courtesy of Sharon and Walt Friedhofen.)

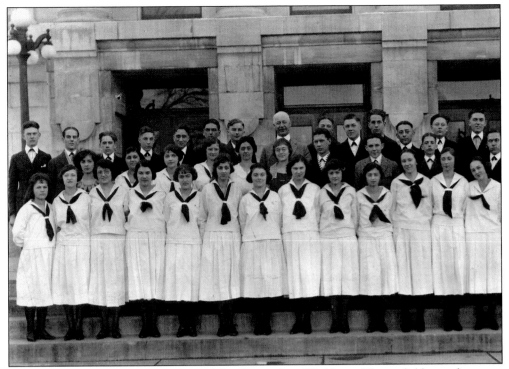

In 1922, these unidentified members of the Queen City Warblers of Springfield were fortunate to have R. Ritchie Robertson (center) as their music director. Professor Robertson, a native of Scotland, became the head of the Springfield Public School Music Department in 1916. He organized many school musical groups and fraternal bands; including America's largest Boy Scout Band and its first All-Girl's Drum Corps, the Kilties. (Courtesy of Jim Hoover.)

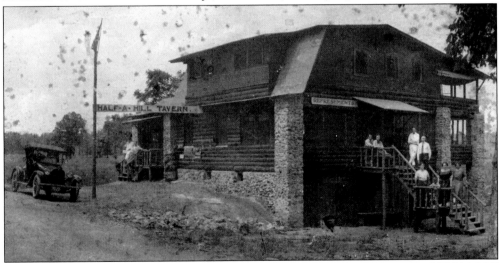

Maude and Walter Hickman opened Half-A-Hill Tavern in 1920. Later renamed Half-A-Hill T-House, it contained a soda fountain, dining room, and dance hall. Big Band–era greats graced the stage including Cab Callaway, Duke Ellington, and Paul Whiteman, who launched Bing Crosby's career. During the 1920s, Tom Mix, king of cowboy films, came from Tulsa, Oklahoma, for a famous 75¢ Half-A-Hill fried chicken dinner. (Courtesy of James Roderique.)

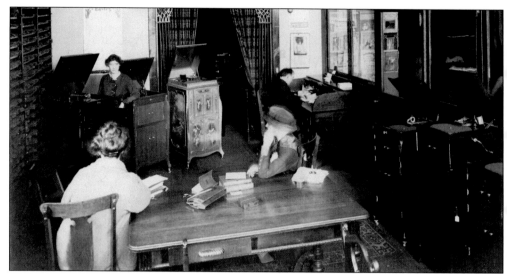

The phonograph department of the Hoover Music Company on McDaniel Street is shown in 1913. Herbert L. Hoover sits at the desk in the business he began in 1912; it is still run by his family four generations later. Hoover Music later moved to St. Louis Street and then to its present location on South Jefferson Avenue. (Courtesy of Jim Hoover.)

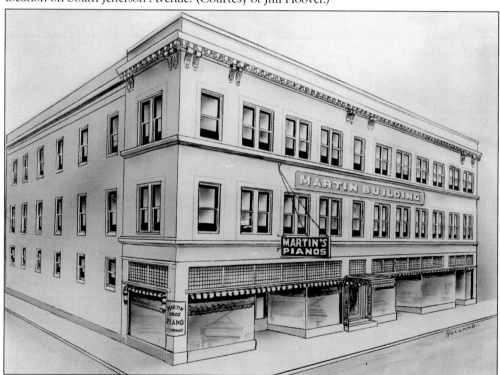

This 1901 drawing depicts the Martin Building on St. Louis Street, which became the new home of the Charles G. Martin Music Store, where sewing machines were sold along with pianos and organs. It incorporated in 1907, becoming Martin Brothers Piano Company. In 1929, Martin Brothers dedicated a storefront window display to the Frisco Railroad's first official song, "Frisco-land" composed by Clyde Fuller, a Springfield relay office employee. (Courtesy of Jim Hoover.)

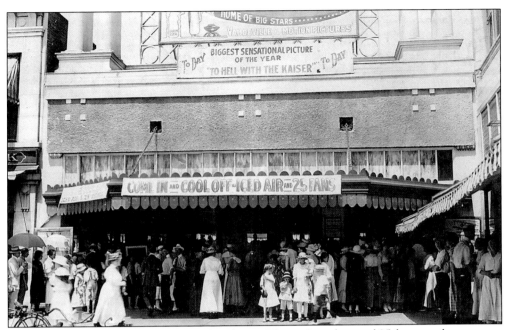

In 1918, moviegoers take advantage of the Electric Theatre's iced air and 25 fans on a hot summer day. Tucked in the northeast corner of the Public Square, this movie palace was originally built in 1916. It offered five vaudeville acts along with the local Keet Orchestra. It burned on December 9, 1947, was rebuilt, and then continued showing films until 1982. Murals by local artist George Kieffer grace the inner hallway. (Courtesy of Midge and Tommy Baker.)

Missouri's highway and bridge builder Maurice E. Gillioz constructed his Gillioz Theatre on St. Louis Street in October 1926. By November, the Gillioz Theatre was sitting on "the Mother Road" when Springfield became the "birthplace of Route 66." The Gillioz Theatre's entertainment included vaudeville, Glen Stambach's organ, and silent films such as *The Waning Sex*, with Norma Shearer, which premiered in1926. (Courtesy of Gillioz Theatre.)

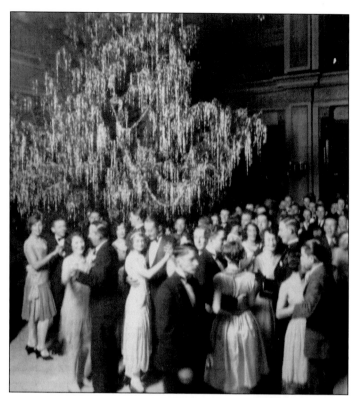

The Colonial Hotel, at the southwest corner of Jefferson Avenue and St. Louis Street, was the site of the U.S. government horse-shoeing shops during the Civil War. The two northern towers were built with a steel frame in 1907, and a third tower was added in 1929. The Colonial Hotel became the temporary home for many politicians and celebrities who visited Springfield during its heyday. A 1920s Christmas party is pictured. The hotel was demolished in 1997. (Courtesy of Blake Stafford.)

On September 27, 1929, the 35th Division, U.S. Army began its annual reunion in Springfield. Two days later, World War I general John J. "Black Jack" Pershing (center) gave a speech at the Shrine Mosque on St. Louis Street. Later, R. Ritchie Robertson's (right) Boy Scout Band presented Pershing with a Boy Scout Band record at the Kentwood Arms Hotel, also on St. Louis Street. (Courtesy of TLC.)

Six

JOIN THE CLUB

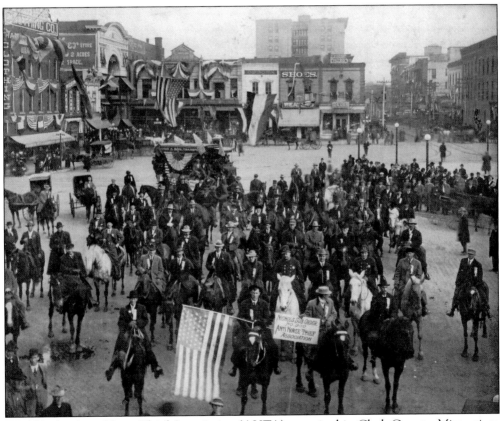

In 1854, the Anti–Horse Thief Association (AHTA) organized in Clark County, Missouri, to protect property, especially horses, which were stolen along border areas between Missouri, Illinois, and Iowa. Members used the court system to bring criminals to justice. The AHTA members were not vigilantes. Their annual membership dues were 20¢. The AHTA's emblem, the horseshoe, represented humanity, charity, and justice. (Courtesy of Scott McCurdy.)

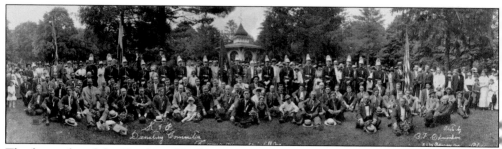

The first order of the Knights of Pythias in Springfield began in 1873, with a membership of nearly 1,000. In 1916, the Knights of Pythias Decorating Committee visits Maple Park Cemetery at Campbell Avenue and Grand Street in honor of Decoration Day. The Uniform Rank (pictured here) numbered 250 and played a large part in Greene County history. (Courtesy of Barbara and David Dershimer.)

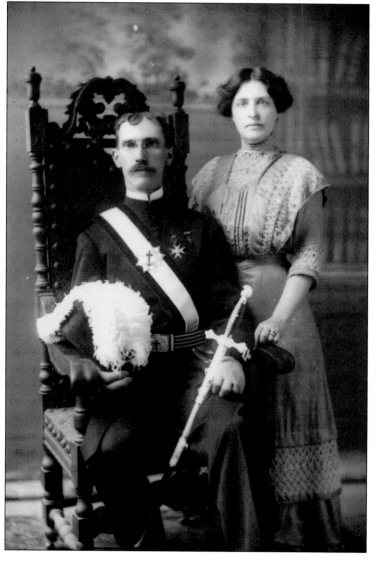

In 1872, the Grand Commandery Knights Templar of Missouri formed the St. John's Commandery No. 20 in Springfield. In 1907, William G. Pike, pastor of the Dale Street Baptist Church, is photographed with his wife, Hattie, wearing his Knights Templar uniform. At that time, Springfield had Greene County's only Knights Templar location, with a membership of around 325. (Courtesy of GCA.)

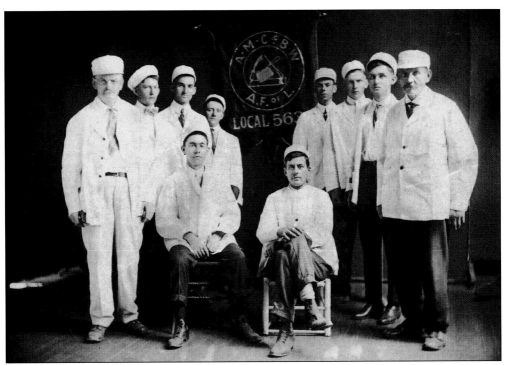

Amalgamated Meat Cutters and Butcher Workmen of North America was chartered in 1897 with seven locals. Springfield Local 563 posed for this photograph in 1917. Pictured, from left to right, are (first row) Bert Adams and Walter W. William; (second row) Charley Takes, Arch Elvy, Stanley Gates, Billy Holmes, Jake Erhentruth, Bill McNaspi, Johnson Mistang, and Claude Williams. (Courtesy of MSU.)

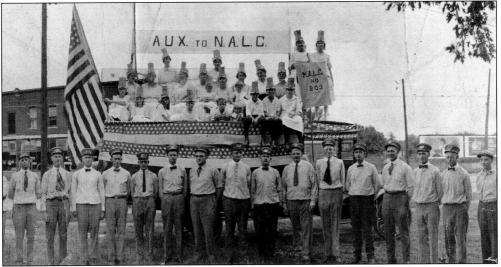

The National Association of Letter Carriers, Local Union 203, stands next to their Labor Day float in 1921. The women from the ladies auxiliary rode on top. The letter carriers in the parade were listed by last names only, from left to right, as Hutchings, Justice, Sage, Cook, Bashers, Blackman, Anderson, Penny, Evans, Hayden, Summers, Walstram, Witherspoon, Hartley, and Penny. (Courtesy of TLC.)

The Independent Order of Odd Fellows, Springfield Canton No. 23 Lodge, pose in front of Grace Methodist Church in 1914. The I.O.O.F. began in Springfield with the Harmony Lodge in 1854. In 1861, the original membership list was lost during the fire that destroyed the Public Square courthouse where the lodge was housed. After the Civil War, the lodge built an Odd Fellows building on South Street. (Courtesy of Jerry Haden.)

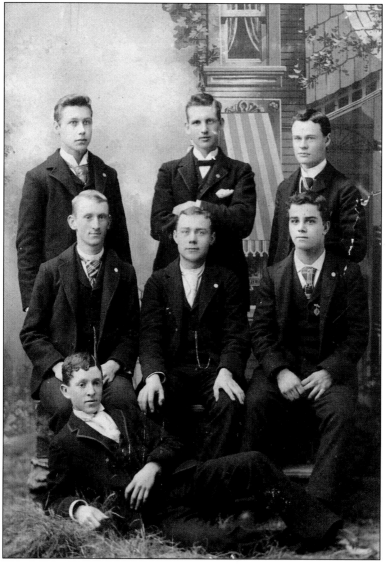

The seven members of the men's Junior Glee Club at Drury College (now University) pose for this photograph in 1891. Charles Melchoir Steineger is in the first row on the far right. Charles worked for his father, Melchoir Steineger, at the Steineger Saddlery Shop while attending Drury College. (Courtesy of Pam Tynes.)

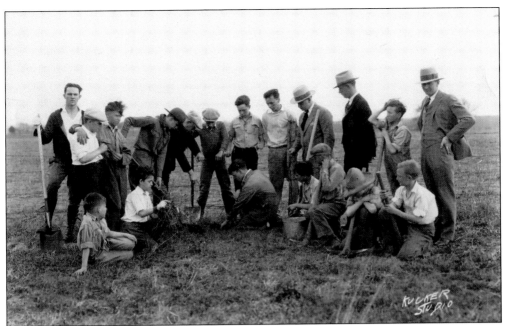

In January 1912, Springfield's first Boy Scout Troop, No. 1, began with patrol leader Joseph Gwathney. Scouts included Claude Elledge, George Newman, John Winn, Charles Hubbard, Joe Lumford, Ralph Peed, Paul Lohmeyer, Earl Rockwell, and Lee Rent. During the 1920s, unidentified Springfield Boy Scouts participate in a Route 66 beautification project with the Springfield Lions Club. Begun in 1921, it is Missouri's second oldest Lions Club. (Courtesy of TLC.)

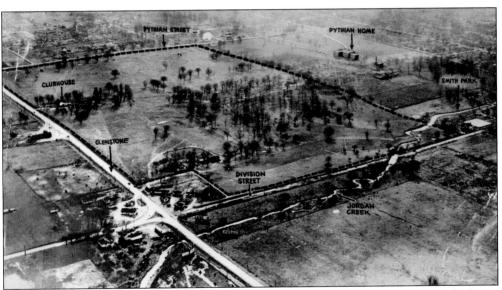

This 1929 aerial view shows the outline for the Glenstone Municipal Golf Course, which was located where O'Reilly Hospital stood during World War II and Evangel University is today. The golf course encompassed the land west of Glenstone Avenue, east of the Pythian Home property, south of Division Street, and north of Pythian Street. (Courtesy of Dorothy Westlake and Evangel University Archives.)

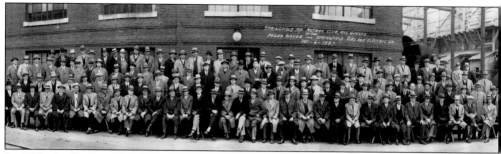

In 1919, the Rotary Club began, and it had 77 members within a year. Their first project was underwriting the salary of the Springfield Boy Scouts of America executive for three years. In December 1927, the Rotary Club's Christmas Committee raised $200 for the County Poor Farm and the Welfare Home for aged and indigent women and visited the power house of the Springfield Gas and Electric Company. (Courtesy of John Ryan.)

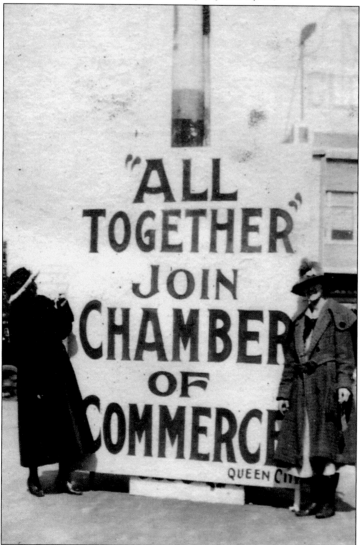

The chamber of commerce formed in 1919 with the joining of five Springfield organizations, including the Springfield Club, which formed as a social club in 1901, and the Young Men's Business Club. Twelve hundred businesses joined, and a campaign for new roads became the chamber's first project. The chamber of commerce rented the Springfield Club building at Walnut Street and Jefferson Avenue for $150 per month. (Courtesy of Midge and Tommy Baker.)

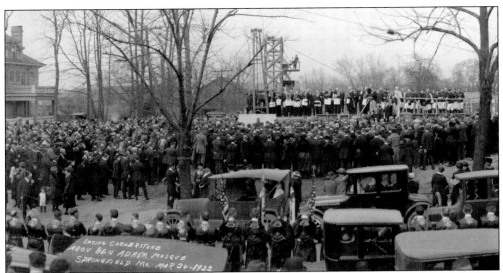

In 1922, the Ancient Arabic Order of the Mystic Shrine held the cornerstone-laying ceremony of the Abou Ben Adhem Temple on St. Louis Street. The four-story Shrine Mosque cost $600,000 and featured 4,750 seats, a stained-glass window by Stanley Uthwatt, the largest pipe organ west of the Mississippi, and a stage second only to New York City's Metropolitan Opera. (Courtesy of Shrine Mosque Abou Ben Adhem Temple.)

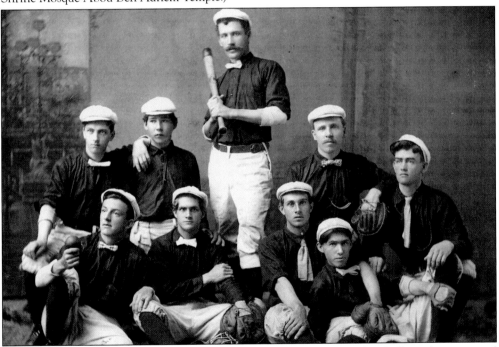

In 1906, George McMillan became Springfield Normal School's first baseball coach in a rented building on Pickwick Street before the main campus at National Avenue and Grand Street was begun. Corliss Buchanan became coach in 1911, followed by Arthur W. Briggs in 1913. Players included, from left to right, (first row) L. S. Crider, J. I. Stow, G. R. Harris, and F. M. Milam; (second row) E. O. Lawing, ? Haryman, J. W. Wray, and O. M. Fumas; (standing) William Northgrave. (Courtesy of MSU.)

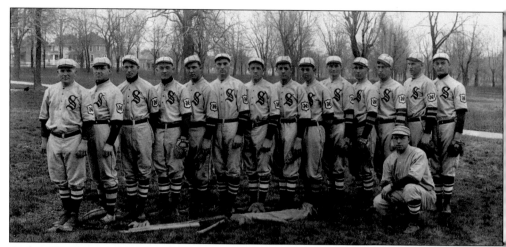

Arthur W. Briggs was the baseball coach of the Southwest Missouri State Teachers College (STC) baseball team for the 1913–1914 season. When he began at STC in 1912, he initiated the annual May Festival celebration, complete with maypoles. The festivities included a parade and the crowning of a May queen. Students, from kindergartners from the Greenwood Laboratory School through STC seniors, all participated in winding the maypoles. (Courtesy of MSU.)

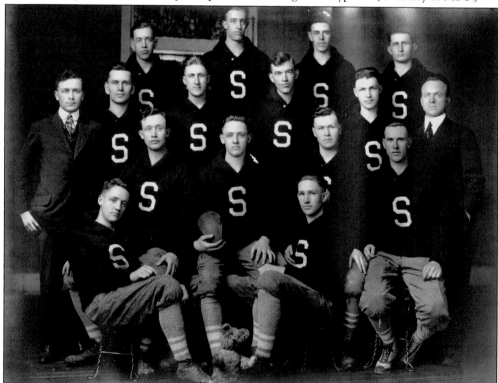

The STC football team members for the 1917–1918 season included Lester (captain) and Chester Barnard, Van Buskirk, Chester Cartwright, Ralph Cheek, Arthur Elkins, Finis Engleman, John Lounsbury, Dietz Lusk, Earl, Mattison, and Milford Greer, Malvin Munger, Leonard Oliver, Will Rainey, Horace Robins, and Ammon Schaeffer. Manager George X. Engleman is in the second row at left, and coach Arthur W. Briggs is in the third row at right. (Courtesy of MSU.)

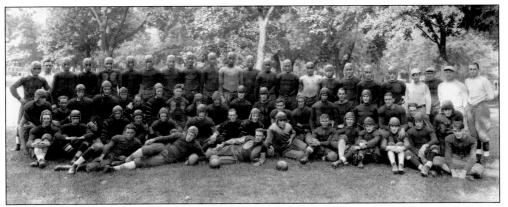

The 1922 football team at STC brought home the Mid-American Intercollegiate Athletics Association (M.I.A.A.) Championship for the first time. The coach, Arthur W. Briggs (third row, second from right), founded the STC athletic program in 1912. Briggs, a tough coach, used psychological tactics to encourage his players. A former STC star athlete from 1914 to 1917, Lester Barnard, later became a coach. (Courtesy of MSU.)

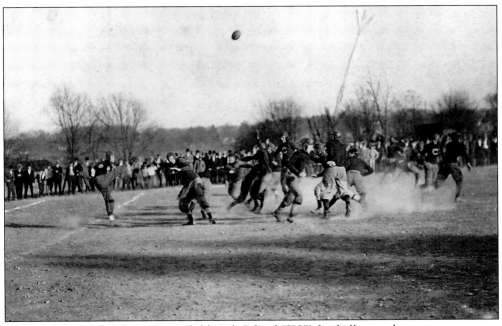

The Carthage High School–Springfield High School (SHS) football game drew many spectators in 1912. The football players averaged less than 160 pounds, which was considered "heavy" in 1912. In 1930, road, bridge, and dam contractor Maurice E. Gillioz began construction on a new $118,000 gymnasium at SHS. It was completed in January 1931. (Courtesy of Betty Jane Rathbone Turner.)

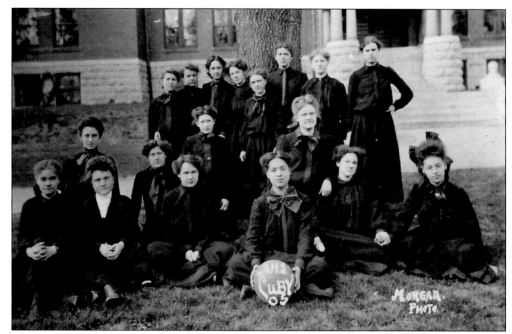

In 1905, the girl's basketball team from Senior High School poses on the lawn where the circle drive is located today. Louise Peak (front, right) became the right forward for the 1908 team. Rumors exist (and they are probably true) regarding tunnels under the high school that can be accessed from the basement boiler room across from the old girls locker room. (Courtesy of TLC.)

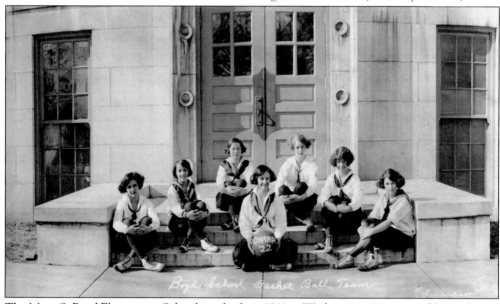

The Mary S. Boyd Elementary School was built in 1911 at Washington Avenue and Lynn Street. The property cost $5,800, and construction expenses ran to $34,208. Josephine O. Young was principal from 1914 to 1948, including in 1922, when the girls' basketball team was photographed. Through 2011, Boyd had only 12 principals, including James Grandon, who began in 2002. Boyd is one of the only two elementary schools in Missouri offering the International Baccalaureate Primary Years Program. (Courtesy of David O'Neill.)

Seven

THE TINKER, THE TAILOR, AND THE CANDLESTICK MAKER

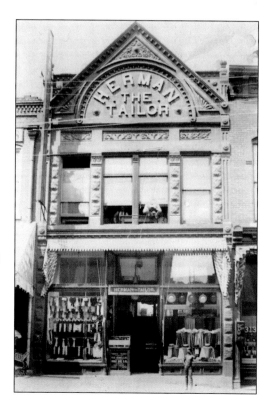

In 1889, Daniel H. Herman, the Herman Tailor Shop owner, appealed a judgment in the Greene County Circuit Court, which Judge Evans awarded to striking tailors. Herman had accused them of not completing their work in an effort to not pay them. He finally admitted the tailors had completed their work and claimed the strike hurt his business. In 1912, Herman moved into the new St. Louis Street McDaniel Building, but he soon moved to 324 St. Louis Street, shown here. By 1916, the tailor shop was Southwest Missouri's largest tailoring establishment. (Courtesy of Gene McKeen.)

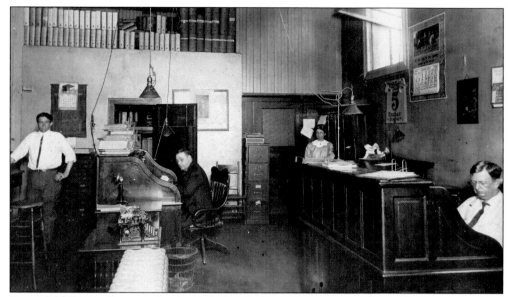

Springfield Grocer Company began in 1865 with Newton M. Rountree (later of Keet and Rountree Dry Goods Company) and Dr. E. T. Robberson. They incorporated in 1889. In the beginning, the company sold dry goods, expanding to include groceries when it moved to Boonville Avenue in 1885. Its private label, the Yellow Bonnet Girl, became synonymous with Springfield Grocer Company, the city's oldest continuously operated business. (Courtesy of Pam Tynes.)

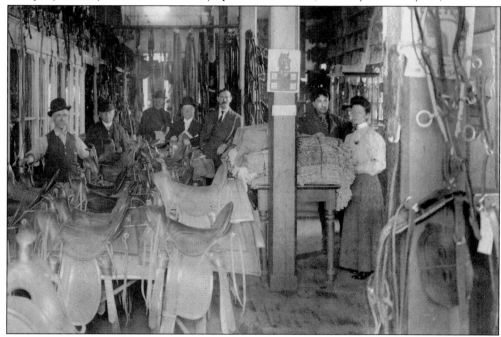

In 1890, from left to right, Harry Heins (Steineger's son-in-law), Melchoir Steineger, Oliver N. Carson, unidentified, M. Y. Messler, Charles M. Steineger, and Maude Lechner posed in the Steineger Saddlery shop. By 1910, James H. Rountree joined the saddlery business. Melchoir Steineger died three years later, and his son Charles Melchoir Steineger took over. Springfield Grocer Company leased the building when Steineger Saddlery closed in 1919. (Courtesy of Pam Tynes.)

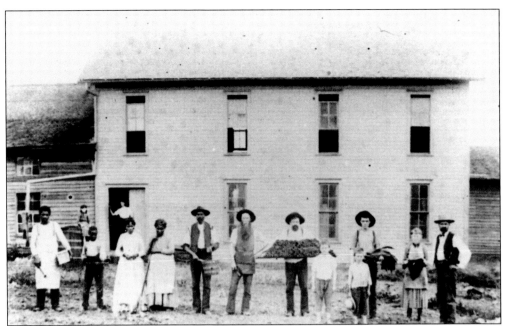

In 1867, George H. McCann built the Old Coon Tobacco Works at Jefferson Avenue and Olive Street, manufacturing 250,000 pounds of tobacco yearly. In 1897, August Engelking and Frank Grubel opened Engelking and Grubel Cigars on Boonville Avenue. They advertised purchasing tobacco from "scientific growers" only to produce their "Frank's Club House" and "Little Puritan" cigars, which they sold for 5¢ and 10¢ each. (Courtesy of MSU.)

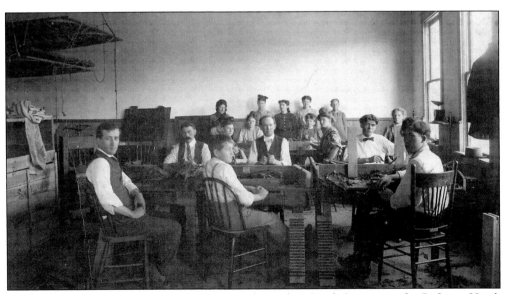

George Fluth's cigar manufacturing business was located on South Street near the St. James Hotel. By 1873, he employed eight St. Louis Labor Union members producing 30,000 cigars monthly. Fluth advertised St. Louis prices but promised savings because there were no freight costs. Plus, he touted, "it kept the money in the Country." The cigar factory is shown in the 1880s with unidentified workers. (Courtesy of Mary Jo Greer.)

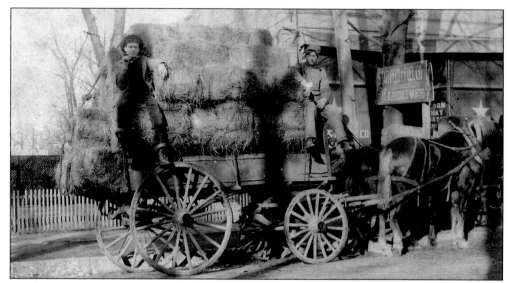

In the late 1860s, two unidentified men stop in front of the Star Feed and Fuel Company store on South Street near the St. James Hotel. In 1872, Mr. Fairman purchased the store, renaming it the Star Meat Market, which still carried flour and feed as well as every variety of fresh meats. Fairman's had been lost in a fire. (Courtesy of Mary Jo Greer.)

Frank E. Headley Sr. built the Headley Block at 302–306 Boonville Avenue in the 1880s. His tenants included Headley and Dunphy (James E.) Grocers; John F. Bigbee and John C. Dingle Real Estate Office; John S. Cunningham, an insurance agent; and Henry Kuhn and Son Photography Company. The Kuhn Photographers advertised a special on a dozen photographs for $1.99 rather than the usual $4. (Courtesy of Gene McKeen.)

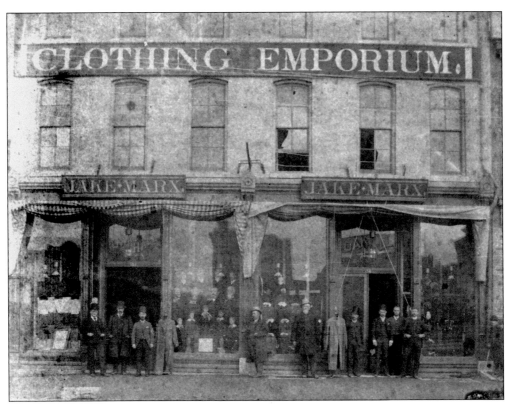

In 1878, Jake Marx partnered in the Cohn Dry Goods business, later buying them out. In 1886, the Grand Opening of Jake Marx's Oak Hall Clothier store was held at the corner of Boonville Avenue and the Public Square. Purchases of $5 or more received a free gift. Jake Marx (third from left) and unidentified employees pose in 1896. (Courtesy of Madeline Innes.)

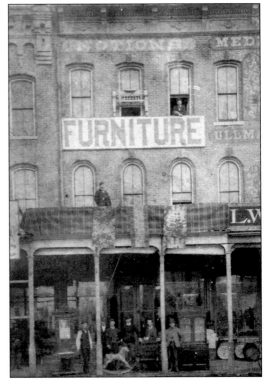

German merchants Lee and William "Willie" Ullmann built the first brick building on the east side of the Public Square in 1870, and they then built the Ullmann and Fearn Building in the mid-1880s. Lee Ullmann and C. K. Dyer ran a drugstore out of the Public Square location (shown in the 1880s) selling paints, oils, glass, furniture, and wallpaper. (Courtesy of TLC.)

Dr. Ludwig Ullmann built the Ullmann Building (shown in 1916) on College Street and Campbell Avenue in the 1870s. In 1890, prominent citizens resided there, such as Supreme Court Judge Thomas A. Sherwood and Springfield White Lime Company president James H. Smith. Established in 1889, the Kentucky Liquor House, on the first floor, offered the finest imported and domestic brandies, wines, and gins for medicinal purposes. (Courtesy of Gene McKeen.)

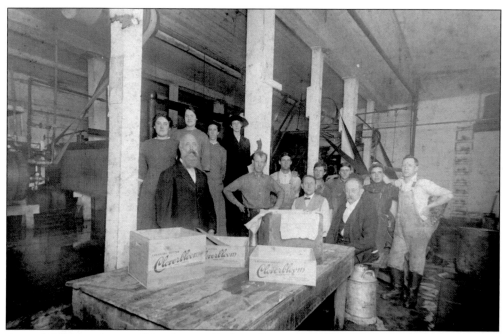

Around 1900, employees of the Armour Packing Company at Water Street and Hayden Avenue pose for a photograph with boxes of their Cloverbloom creamery butter. After a fire in 1913, Armour merged with the Swift Company, becoming the Swift and Armour Packing Company, dealing in supplies of meat, fish, poultry, eggs, and produce. (Courtesy of Allie Roberts.)

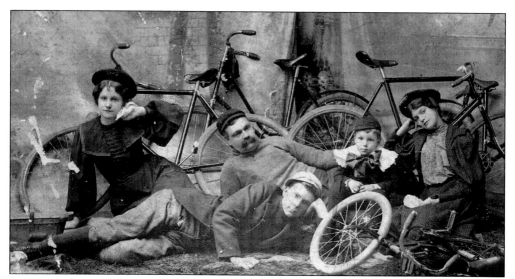

In 1897, Lycurgus E. Lines (center), founder of Lines Music Company, is photographed with his children, (left to right) Daisy, Morton, George, and Pearl, four years after starting his company. During the Civil War, Lines served with the Union army at only 13 years old, allowing him to vote for Abraham Lincoln for president at only 16 years old. Lines Music Company closed in the 1980s. (Courtesy of Alice Dodd.)

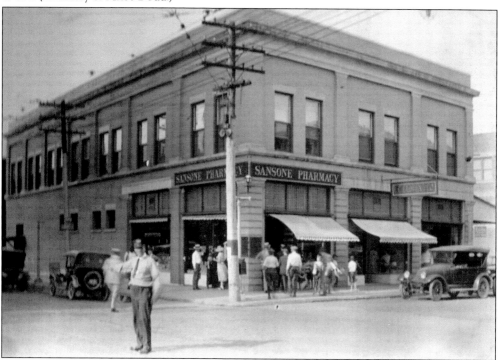

After losing their restaurant to the 1909 Baldwin Theatre fire, Charles and Angeline Sansone managed John T. Woodruff's Sansone Hotel, which opened in 1911. After 11 years, Charles Sansone opened Sansone's Drug Store (shown in 1922) at the northeast corner of St. Louis Street and Jefferson Avenue in a building that had burned in 1921. Thousands attended the open house on July 22, 1922. (Courtesy of Blake Stafford.)

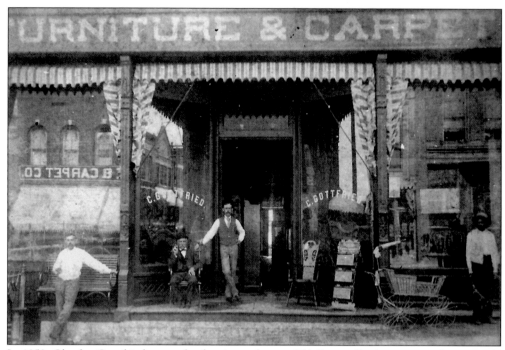

In 1858, Charles Gottfried opened a furniture shop at 324 Boonville Avenue, on the east side of the street between Olive Street and Mill Street. Charles and his son, Conrad, continued to run their business from this location, renaming it the Gottfried Furniture and Carpet Company. Later, William H., Albert F., and Dr. Charles F., the third generation of Gottfried men, took over running the business. (Courtesy of TLC.)

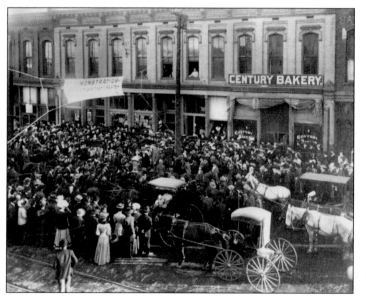

In 1902, a crowd gathered on Commercial Street in front of Cormack and Rathbone's Hardware Store and the Century Bakery for a demonstration of Moore's Air-Tight Heaters by Moore Brother's Company from Joliet, Illinois. New product demonstrations were a huge event for citizens at the beginning of the 20th century. Coffee and biscuits were served free to all. (Courtesy of Flowers Pentecostal Heritage Center.)

In 1874, Thomas Henry Rathbone opened a hardware store with his son, James Henry, and grandson, Barney. In 1897, James opened a second store with John F. Carmack. James (right) and employees Frank Goddard (left) and John Alsup pose in Rathbone Hardware during 1906. Great-great grandson Timothy Henry Turner currently operates Rathbone's Ace Hardware with his son, Robert Henry Turner, the sixth generation. (Courtesy of Betty Jane Rathbone Turner.)

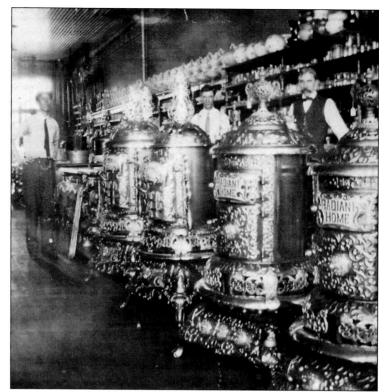

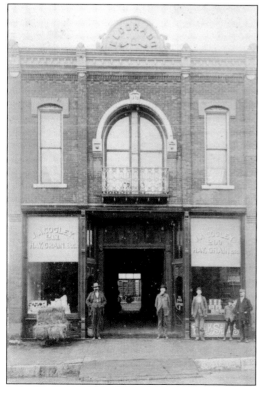

In 1900, John A. Cogley ran a feed business on Commercial Street in the Eldorado Building, named for his wife. After John's death in 1901, his son Lewis N. Cogley and Joseph E. Peltz opened a shoe business. Cogley and Peltz joined the fraternal organization the Kiowa Tribe No. 38, Improved Order of Red Men, instituted by the Great Chiefs of the Reservation of Missouri in July 1899. (Courtesy of Jerry Haden.)

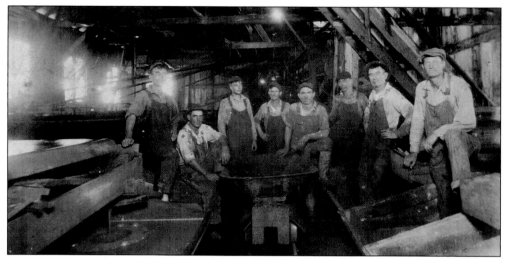

In 1840, Missouri became the first state west of the Mississippi producing coal commercially. By 1881, Missouri's coal fueled the locomotives, and coal mining became its major industry. In the early 1900s, these unidentified miners pose in the St. Louis Street Mine Shaft No. 3, possibly near Springfield's cotton mill, where a 2-foot-wide bed of bog iron ore was discovered in 1886. By 1918, coal production swelled, remaining between three and six million tons per year over the next six decades. Joseph Wise Post stood beside his diesel engine in the 1950s. Declining locomotive use in the 1950s and 1960s dropped coal production, but increased coal-fired powered plants in the 1970s spiked production, and the state's output peaked at 6.7 million tons in 1984. (Above, courtesy of Rose Jones; below, courtesy of Caroline Post Netzer.)

In 1894, the John F. Meyer and Sons Milling Company began at Phelps Street and Boonville Avenue. Meyer and sons Ferdinand, Herman, Henry, and Louis produced 700 barrels of flour daily, which were distributed overseas and domestically. In 1901, a new mill was erected at National Boulevard and Pine Street (now Tampa Street). By 1914, the company had 60 employees. An unidentified man directs traffic in 1900. (Courtesy of Blake Strafford.)

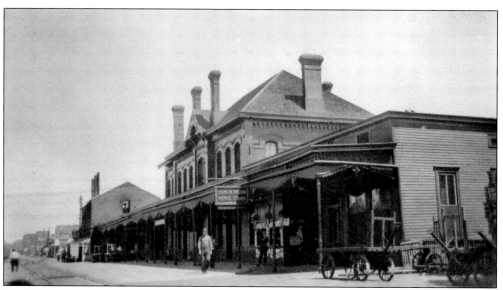

In 1882, a two-story railroad station at the corner of Mill and Main Streets was built. It included a Fred Harvey Company lunchroom, electric lights, and steam heat. The Springfield Frisco Depot is shown around 1910, with the lunchroom sign visible. In 1927, it was completely remodeled in a California mission style. The Springfield Fred Harvey Restaurant was the last to close in 1955. (Courtesy of TLC.)

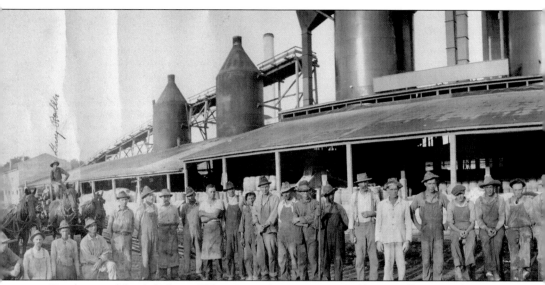

Employees of the Ash Grove White Lime Association in Galloway Village pose for a photograph in 1905. Identified are Gary Roller (left) and Dan Jones (right) on horses and Charley Beshears driving the buggy. Identified in the row of workers are Linnie McDaniel (3rd from left), Rich Williams (5th), George Snow (6th), Albert Jones (10th), W. T. Sisco (13th), John Denny (14th).

Unidentified women posed in 1924 in front Reps Dry Goods and the Electric Theatre in the northeast corner of the Public Square. They wore their entries for Reps's 1899 dress contest, being held as an advertising gimmick for its 25th anniversary. William Reps began the business in 1899, and his son, Louis, joined him in 1911. After a fire in 1939, Louis Reps closed the store and became executive director of the Springfield Chamber of Commerce. (Courtesy of Jerry Haden.)

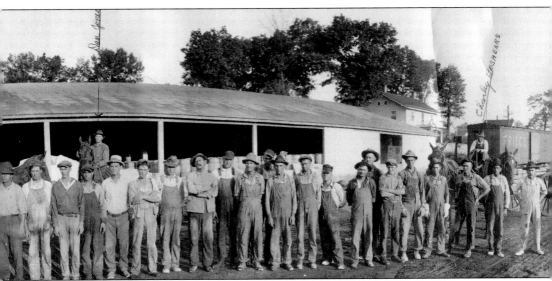

John Hooper (16th), Jack Lee (17th), Harry Hooper (21st), Red Hooper (22nd), Oscar McDaniel (23rd), Charley Hayden (26th), Jim Walker (30th), Alex Jones (31st), Fred McAmis (32nd), Noah Jones (34th), Henry Williams (35th), Bo Dyson (37th), Tod Garrison (38th), Landon Reed (42nd), Jim Bateman (43rd), and George Eldridge (46th). (Courtesy of Danny and Irene Jones.)

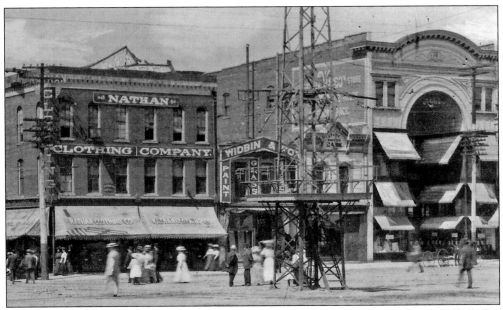

William Widbin began Ward and Widbin paint and wallpaper store in 1900. By 1904, E. B. Fox replaced Ward, forming Widbin and Fox Paint Company, which incorporated in 1912. The fire in the northeast corner of the Public Square in 1913 left Widbin and Fox homeless, so they established offices in their Pickwick Street warehouse. By 1914, they reopened on East McDaniel Street. Widbin and Fox was between Nathan Clothing Store and State Savings Bank. (Courtesy of Blake Strafford.)

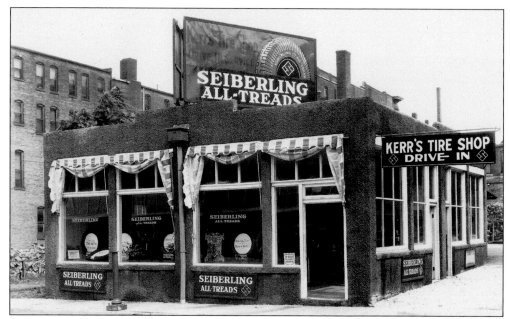

In 1921, Leo Kerr closed his tire shop in Neosho, Missouri, and relocated to Springfield with his bride. Leo opened Kerr's Tire Shop at Patton Alley and East McDaniel Street. It was one vacant lot away from the Metropolitan Hotel, which faced College Street. The "Met" was the socialites' place to be seen before the Depression, during which Leo lost the Kerr's Tire Shop. (Courtesy of Tom Kerr.)

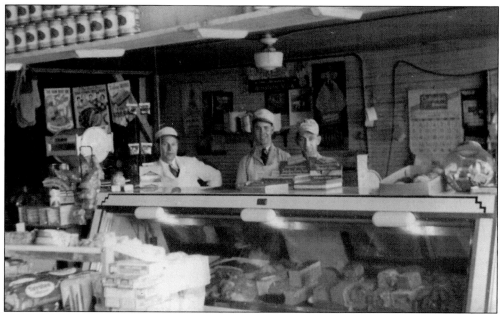

The Roberts Meat Market was located at 522 College Street and Main Avenue in 1922. College Street headed west out of the Public Square and became part of Route 66 in 1926. Behind the counter are, from left to right, owner Harley H. Roberts, Louis Bland, and Paul Mafreanskie. Harley's son, Harvey Lloyd "Buddy" Roberts, later took over the Roberts Meat Market business. (Courtesy of Jean Ann Roberts Coberly.)

In 1869, Charles H. Heer opened the Charles H. Heer Dry Goods Company on Boonville Hill. It became the second incorporated retail store in Missouri. When his father retired in 1886, Francis Xavier Heer became manager. When F. X. Heer built his northwest Public Square and College Street building in 1913, the Heer Store was billed the "Dominant Store of the Ozark Empire." (Courtesy of Jerry Haden.)

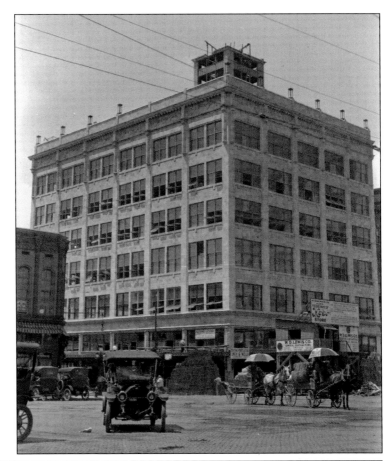

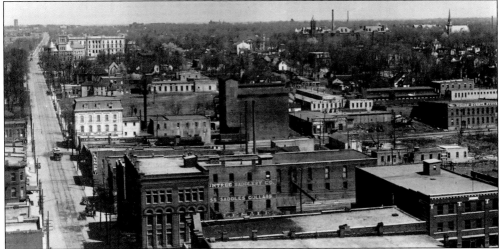

This 1915 photograph was taken from the top of the Landers Building at the northwest corner of Boonville Avenue and the Public Square. Kate Holland Keet began what was originally called the Keet Building. In December 1914, Douglas J. Landers purchased it mid-construction, renaming it the Landers Building. The Senior High School is visible in the background, including the third section completed for $120,000 in 1914. (Courtesy of Blake Stafford.)

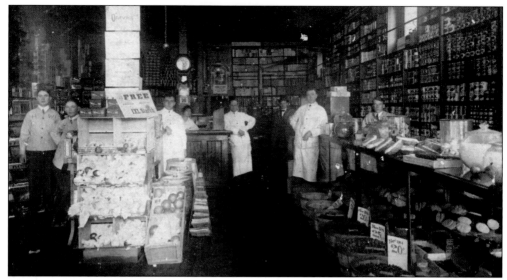

The Hickman-Waddle Grocer's employees pose for a photograph in 1914. Walter C. Hickman (seventh from left) and Henry E. Waddle co-owned the store on East Walnut Street from 1914 until about 1919. The store was a member of the Springfield Retail Merchants Association, which began in 1900, and had 150 members. Hickman and his wife, Maude, opened Half-A-Hill T-House in 1920. (Courtesy of Pat Boren.)

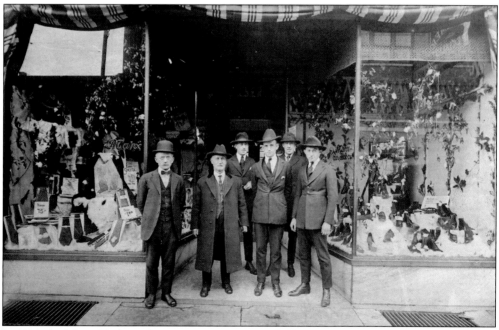

In 1916, the Marx Clothing Store owner, Gus Marx, (left) poses with his former business partner and brother, Jake Marx (second from left), at the St. Louis Street store they relocated to in 1912. Gus' sons Mannie, (front, third from left) and Arthur (back, left) ran the store. Gus Bowen (front, right) was top salesman. Holland Chalfant (back, right) was a *Springfield Leader* newspaper reporter. (Courtesy of Madeline Innes.)

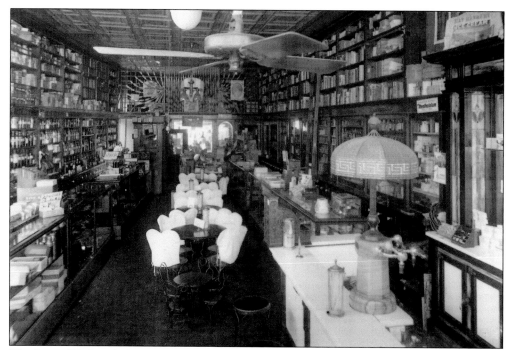

The James W. Crank Drug Company, which grew to six locations, is photographed in 1915 on Commercial Street. James E. Crank was recorder for the Springfield District Court of Honor No. 834, which organized with 48 members in 1894. By 1914, it had 800 members. He was also a director of Peoples Bank at Commercial Street and Boonville Avenue, which chartered in 1909. (Courtesy of GCA.)

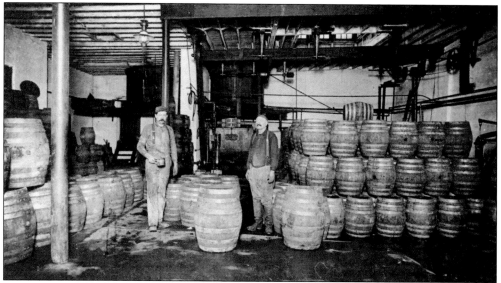

Sebastian Dingeldein worked St. Louis's largest breweries after emigrating from Germany in 1867. In 1872, Buehner and Finkenauer built their College Street brewery, which produced 800 barrels of beer per day. In 1876, Dingeldein leased the brewery. In 1882, he bought it, changing the name to Dingeldein's Brewery and increasing production to 2,100 barrels per day. Sebastian Dingeldein, left, is pictured with an unknown brewery worker in 1916. (Courtesy of MSU.)

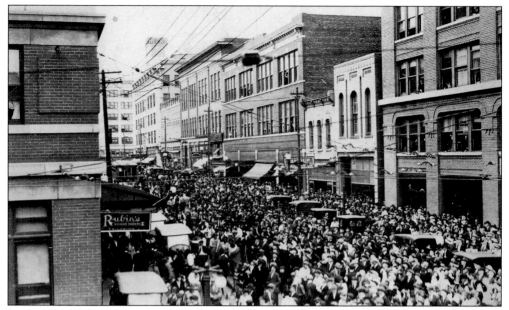

In the mid-1920s, thousands of people stand elbow-to-elbow on St. Louis Street. They appear to be watching an event taking place at or above either the McDaniel Building or the Sansone Hotel. The McDaniel Building, built in 1912, replaced the Baldwin Theatre, which was destroyed by fire in 1909. The Sansone Hotel, built in 1911, later became the Sterling Hotel. (Courtesy of Madeline Innes.)

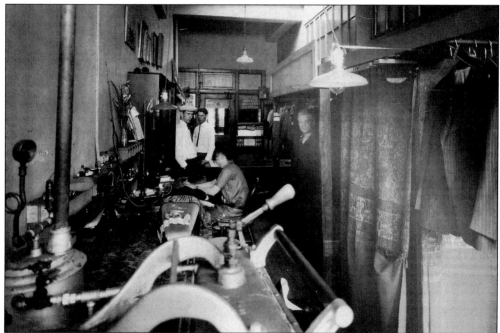

The Friedhofen Tailor Shop was located behind the lobby in the McDaniel Building on St. Louis Street. Andrew, Gus, and Walter R. Friedhofen, along with Andrew's daughter, Irene, are shown in the tailor shop in 1920. The tailor shop was one of the first occupants in the new McDaniel Building when it opened in 1912. (Courtesy of Sharon and Walt Friedhofen.)

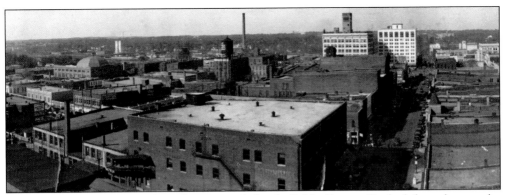

This 1920s northward view of South Street includes the Public Square. To the left can be seen the 1913 convention center dome on the west side of South Campbell Avenue between Walnut and College Streets near the Old Calaboose police station. The three-story convention center, called the "Hippodrome," was a theater and entertainment center. When first built, it was considered the largest convention center in Southwest Missouri. (Courtesy of Nancy Brown Dornan.)

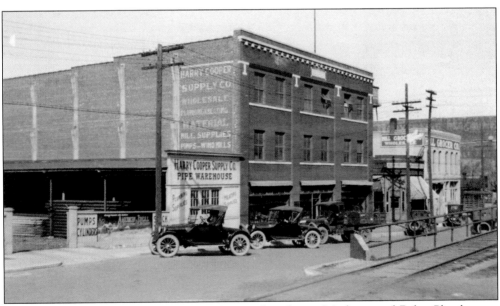

In 1886, Harry and his brother, George Cooper, bought out Mathews and Baker Plumbers on South Street for $245, beginning Cooper Brothers Plumbing and Heating. Harry bought George out for $3,801 in 1908, changing the company name to Harry Cooper Supply Company. In 1921, Harry Cooper sits inside Car No. 1 of the company fleet of automobiles in front of the Water Street Location, built in 1908. (Courtesy of Harry Cooper.)

James A. Tindle started at the Ozark Water Mill on the Finley River. By 1912, Tindle opened a Springfield branch, and in 1918, the Springfield Wholesale Flour and Food Company incorporated. Building a $40,000 concrete grain elevator that held 150,000 bushels (shown in 1929) on Chestnut Street in 1928 allowed expansion throughout the Ozarks. The Tindle Mills stock value then jumped from $75,000 to $100,000. (Courtesy of Pete Radecki, Drury University.)

In 1914, Louise Holland Jarrett built the Holland Building in honor of her father, Telmachus Blondville Holland, on land she inherited after his 1913 death. Holland, once described as one of the wealthiest citizens in Greene County, lost many properties during the 1913 Public Square fire. In 1922, doctors began a medical clinic in the Holland Building that continues today as the Smith-Glynn-Callaway Clinic in Springfield. (Courtesy of Allen Casey.)

Ely Paxson moved to Springfield in 1867 and helped establish the undertaking business that later bore his name. In 1899, he became president of the Funeral Directors Association of the State of Missouri during the yellow fever outbreak. Paxson married Anna Belle Keet, daughter of James Keet, Springfield Grocer Company's vice president and Greene County National Bank's president. Paxson exhibits his hearses on South Street in 1924 above. (Courtesy of Lohmeyer Funeral Home.)

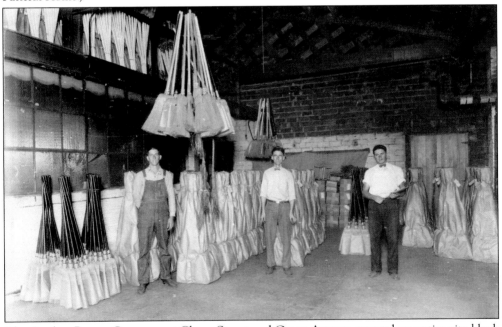

The Anchor Broom Company at Chase Street and Grant Avenue covered an entire city block with two broom corn warehouses, a constructing warehouse, and an office. Incorporated in 1901, it became Southwest Missouri's most successful broom works with superior quality and famous brands. Mops became an instant success when added in 1910. Company employees photographed in the warehouse in 1927 are, from left to right, unidentified, Bill Appleby, and Richard O'Neill. (Courtesy of David O'Neill.)

In 1887, Lee Savage founded the Lee Savage Paint and Glass Company. His grandfather, Daniel Boone Savage, settled in Springfield in 1869. In 1915, Irene, Lee's oldest child, joined the company. Irene ran the business from Lee's death in 1925 until it closed in 1935, while her brothers entered other branches of painting and decorating. (Courtesy of MSU.)

In 1923, Jessie McCurdy opened McCurdy Paint Company. In 1930, (left to right) her father, William L. McCurdy, a customer, her brother, Claude H. McCurdy, and possibly an errand boy, were photographed at their Commercial Street location. After WWII, Claude's son, Bill McCurdy, became manager. McCurdy's relocated to Sunshine Street in 1952, keeping pace with the city's southward movement. In 1980, they sold the business. (Courtesy of Dorothy and Bill McCurdy.)

Eight

EDUCATION, THE BACKBONE OF SOCIETY

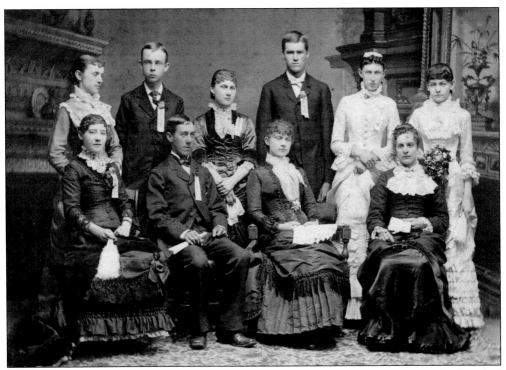

In April 1850, Southwest Missouri High School opened in Springfield. In 1868, the board of education purchased lots at Jefferson Avenue and Olive Street for $3,850, and the Central School was completed three years later for $19,150. Charles C. Hutchinson served as principal, with Henry Richards as assistant principal. In 1881, graduates were photographed as Jonathon Fairbanks began his 30-year career as school superintendent. (Courtesy of TLC.)

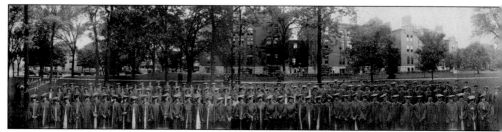

The 1921 Senior High School graduating class contained 66 boys and nearly twice as many girls. They held their graduation ceremony, themed "the Celebration of the 300th Anniversary of the Landing of the Pilgrims," at the Jefferson Theatre. The High School Orchestra and Senior Girls Glee Club performed. Principal L. A. Doran, presented the class, and Superintendent of Schools W. W. Thomas awarded diplomas. (Courtesy of David O'Neill.)

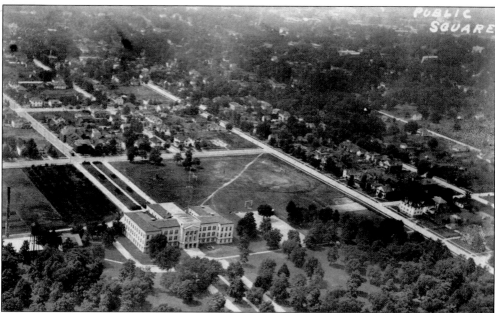

On August 10, 1907, the cornerstone was laid on Academic Hall, the first building at Southwest Missouri State Teachers College, which was completed in 1909 (shown). Renamed Carrington Hall after the college's first president, William T. Carrington, it is currently the administration building. The Education Building opened with 8,500 attending an open house in 1924, and the Science Building was completed in 1927. (Courtesy of MSU.)

In August 1925, the students of Southwest Missouri State Teachers College celebrate the end of the summer term with a day around the lake at Doling Park. Many were probably recent STC graduates. Up until 1926, commencement exercises were only celebrated at the end of the summer term for the entire year. Beginning in 1926, commencement exercises were held in both spring and summer. (Courtesy of Kristi Bench.)

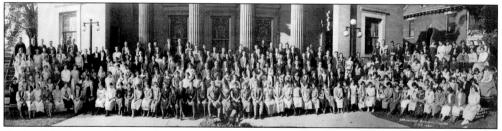

Springfield Business College began in 1906, when the Normal Business College, the business department of Springfield Normal School, combined with Queen City Business College. John A. Taylor served as president. A scholarship program in 1908 offered room and board for $3, which included utilities, a bathroom, towels, soap, and matches. It offered typewriter repair courses for $5 and railroad bookkeeping for $50. It occupied the southwest corner of Jefferson Avenue and Walnut Street (Courtesy of TLC.)

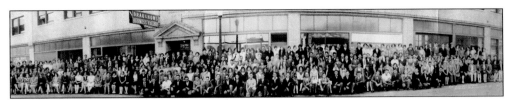

In 1927, Draughon Business College students pose in front of the E. M. Wilhoit Building on Pershing Way (now Pershing Street) at Jefferson Avenue. The 100,000-square-foot building was built in 1920 and was considered the largest office space in Springfield at that time. The school occupied the entire upper floor for decades. The school opened in 1914 at 218 1/2 East Walnut Street. (Courtesy of TLC.)

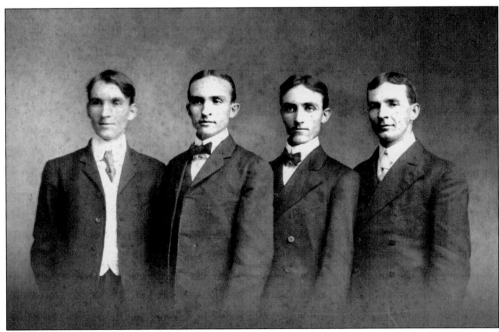

Pictured from left to right are Lewis Elbern Meador with his brothers Ely, Fred, and Clarence around 1905. Born in Cassville in 1881, Dr. Lewis Meador began a 43-year long career teaching at Drury College (now University) in 1913. In 1945, Meador helped draft Missouri's constitution, and in 1953, he assisted in writing a new city charter for Springfield. In 1973, L. E. Meador was named "Springfieldian of the Century." (Courtesy of Leeson Cordoza.)

In 1907, a silk flag was attached to Stone Chapel's steeple by five freshmen. They were Victor E. Russom, Elbert Evans, John Tooker, Billy Knight, and John Miller. It stayed there until it rotted, because nobody knew how to remove it. The same class erected a mock cemetery in front of Stone Chapel with appropriate epitaphs for faculty members and then placed a cow in the bell tower. (Courtesy of Drury University Archives.)

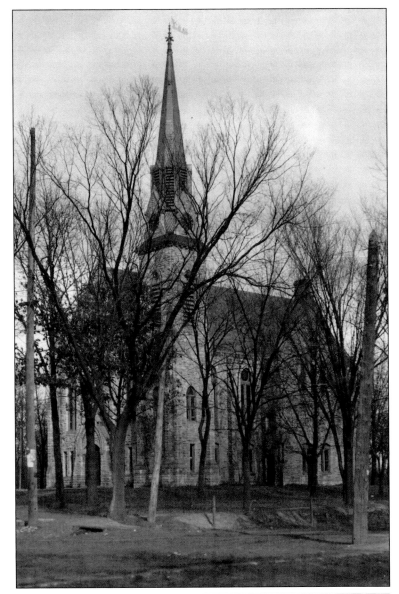

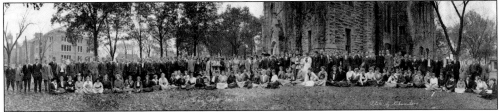

In 1913, Drury College (now University) students posed near Stone Chapel at the northeast corner of Benton Avenue and Center (now Central) Street. Stone Chapel, one of the oldest surviving buildings on the Drury campus, was begun in 1881. It burnt in 1882, was rebuilt with funding from Springfield citizens in 1883, and was finally completed in 1892 at a cost of $45,000. (Courtesy of Drury University Archives.)

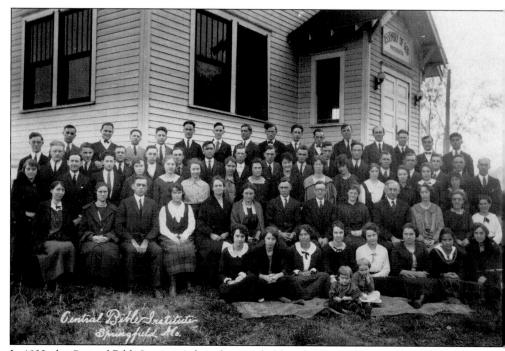

In 1922, the Central Bible Institute's first class was held in the Central Assembly of God's basement at Campbell Avenue and Calhoun Street. City businessmen contributed $5,000 to purchase 15 acres at North Grant Avenue and Norton Road. Bowie Hall was completed in 1924. Central Bible College's first graduating class was in 1925. The campus now comprises 32 acres. (Courtesy of Flowers Pentecostal Heritage Center.)

In 1878, the Sisters of Loretto opened a young ladies' academy at Campbell Avenue and Pine Street (now Tampa) with a three-room frame cottage and a two-story brick building. Later, a three-story, 60-room brick building was erected to accommodate 200 pupils. Mary Lyons (back, third from left) and fellow students pose at the Loretto Academy May 13, 1906. The academy closed on November 17, 1919. (Courtesy of Sally Lyons McAlear.)

Rented buildings were used until a lot at Washington Avenue (now Drury Lane) near Center (now Central) Street was purchased for the Washington Avenue Colored Public School in 1872. A two-story, four-room brick school was built in the African American neighborhood. In 1884, Drury College replaced it with the two-story brick Lincoln High School. Douglas School at Market Avenue and Grand Street was built in 1891 for elementary grades. Nana Adams was the first librarian when the Lincoln School library opened in 1917 with 465 volumes. By 1922, there were 1,104 books valued at $1,798. In 1930, Douglas and Old Lincoln High Schools were closed. New Lincoln School was built at Sherman Avenue and Central Street. Lincoln became Eastwood Junior High following the 1955 state-mandated desegregation and closed in 1962. (Above, courtesy of Pauline Diemer; below, courtesy of Betty and Homer Boyd.)

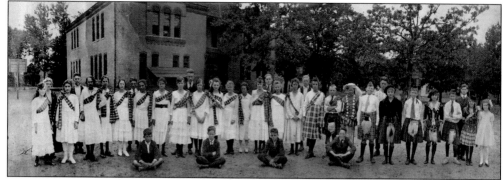

Berry School was built at the northeast corner of Sherman Avenue and Division Street in 1887. It was named for county official and local businessman Daniel Berry. In 1919, some Berry School students dressed in Scottish Highland kilts and sporrans. Vince Plaster, the photograph's owner, states this group was the predecessor to the Kilties Drum and Bugle Corps at Senior High School (now Central High School). (Courtesy of Vince Plaster.)

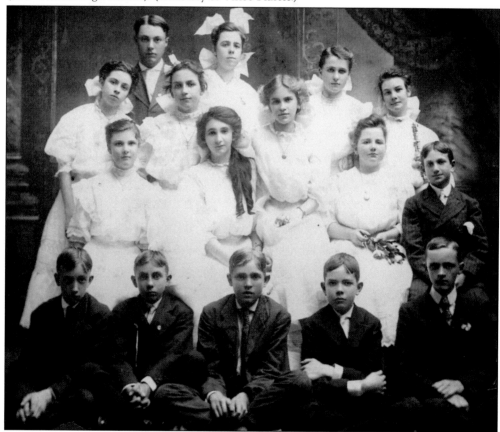

In 1908, Arthur Marx Sr. (second row) poses with unidentified classmates for a year-end photograph during Greenwood Laboratory School's first year. Greenwood was not technically a private school, but as a laboratory school it required tuition. Springfield Catholic High School was established in 1916. A private school supremacy war sprang up between Greenwood and Springfield Catholic that became one of the longest crosstown rivalries until Greenwood's football program was discontinued in 1995. The schools still compete in basketball and soccer. (Courtesy of Madeline Innes.)

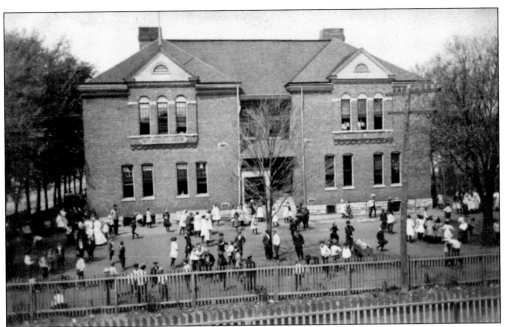

When North Springfield's school district consolidated on April 7, 1888, the 6th Ward School was renamed Weaver Elementary School after Joseph Weaver, a former Springfield mayor. In 1895, an addition was built for $5,000 when the school district enrollment reached 5,155. An addition was built in 1901, but Weaver Elementary School was finally replaced by a new building on Douglas Avenue and Division Street. (Courtesy of Vince Plaster.)

In 1909, the Mothers' Circle began at Mary S. Boyd School. In 1913, they joined with other Mothers' Circles, becoming the first Parent-Teacher Association (PTA) in Springfield. They addressed sanitary needs, the library, classroom ventilation, and "Operation Toothbrush Drill." Pictured are Kewpie creator Rose O'Neill's nephew, Richard O'Neill (back, third from left), and niece, Mary O'Neill (front, fifth from left), with other unidentified students at Boyd School on Washington Avenue in 1919. (Courtesy of David O'Neill.)

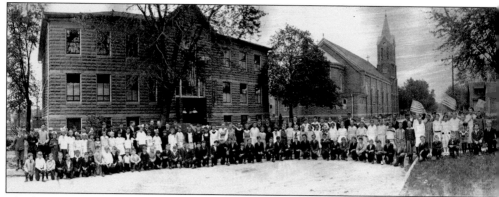

Charles H. Heer bequeathed $15,000 to build a new St. Joseph's Church and school after his death in 1898. Between 1904 and 1907, property on Scott Street at the corner of Campbell Avenue was purchased for $5,740. The new St. Joseph's Church and school were erected at a cost of $42,000. In late 1908, St. Joseph's School opened with 130 children, including John Joseph Prugger. (Courtesy of John and Dorothy Prugger.)

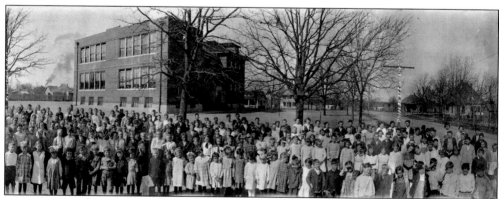

In 1919, Robberson School students pose for a photograph. Robberson School was built for $7,500 in 1905, and a $13,000 addition was built in 1912. It was named for Dr. Edwin T. Robberson, the first school board treasurer in 1867. He was also a well-respected physician and National Exchange Bank president. In 1873, Robberson contributed four lots on Benton Avenue to Springfield College (now Drury University) worth $1,650. (Courtesy of GCA.)

Nine

CALAMITIES, CATASTROPHES, AND OTHER CRISES

Gen. Nathaniel Lyon, the first Union general to die during Civil War combat, was depicted in *Harper's Weekly* at what reporters dubbed the "Battle of Springfield." The Civil War engagement depicted was the Battle of Wilson's Creek, about 12 miles southwest of Springfield. The Second Battle of Springfield took place two years later, when Confederate general John Marmaduke attempted to capture the city. (Courtesy of William Lee.)

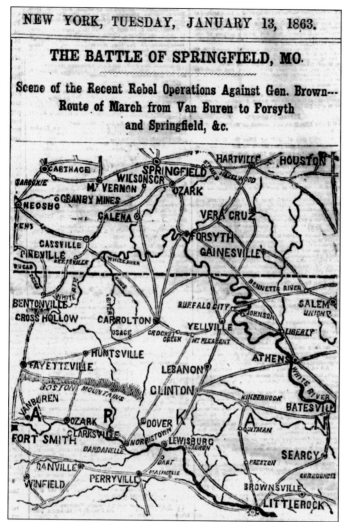

NEW YORK, TUESDAY, JANUARY 13, 1863.

THE BATTLE OF SPRINGFIELD, MO.

Scene of the Recent Rebel Operations Against Gen. Brown---
Route of March from Van Buren to Forsyth
and Springfield, &c.

The Battle of Springfield occurred January 8, 1863. Confederate forces under Gen. John Marmaduke destroyed the telegraph to Fayetteville, Arkansas and attempted to capture Springfield, the West's most important military depot. Fort Lyon, one of five Springfield Civil War forts, held provisions valued at $1 million. One hundred men died before Gen. Egbert Brown's 2,099 Union men, including the sick and wounded known as the "Quinine Brigade," repulsed the Confederate attack. (Courtesy of Savannah Roberts.)

After serving in the Confederate's Missouri State Guard in 1861, Samuel T. Brannock was one of several men from the Springfield area who, in 1862, enlisted in the 3rd Missouri Cavalry of the Confederate States of America. The unit served with Gen. Jo (Joseph) Shelby in the Trans-Mississippi Department. They fought in many skirmishes during Gen. John Marmaduke and Gen. Sterling Price's expeditions into Missouri. (Courtesy of Karen Morton Yancey.)

Eighteen-month-old Willie died in September during the smallpox and yellow fever epidemic of 1899. His parents, George and Marie Fisher, wanted to record his likeness, so they brought him to Simon H. Wickiser's Photography Studio on St. Louis Street. The Sisters of Mercy from St. John's Hospital volunteered at the pest camp on Bolivar Road north of Springfield, where the sick were quarantined during the epidemic. (Courtesy of Chris Thiessen.)

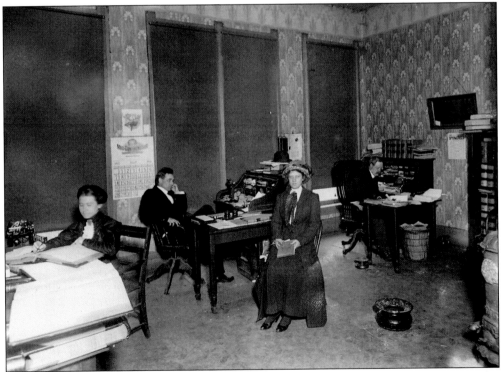

Judge Azariah William Lincoln (right) and his son, Harold Thomas Lincoln Jr. (left, named after his grandfather), sit in their Lincoln and Lincoln law office in 1911. Judge Lincoln called for a grand jury in the 1906 lynching of James Copeland, William Allen, and Harry Duncan. The men were forcibly removed from the jail, hung from the Public Square's Goddess of Liberty tower, and then burned in front of 3,000 witnesses. (Courtesy of Randy Forehand.)

Fifth from left, Mabel "Mina" Edwards poses with her sisters around 1900. In 1906, Edwards's false accusations caused the lynching of three black men in Springfield Public Square. The lynchings led to an exodus of nearly half of the estimated 2,300 black citizens. Lost were productive community members such as doctors, attorneys, business owners, and civic leaders. By 1910, only four percent of the black population remained. (Courtesy of Twyla and Dave Choate.)

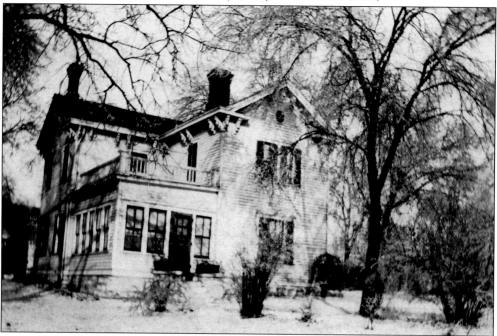

Prof. Jonathon Fairbanks was superintendent of schools for 37 years, beginning in 1875. After the lynching of three black men on the Public Square in 1906, Fairbanks sheltered several black families in his home (shown around 1910). In 1930, Fairbanks's home at Center (now Central) Street and Sherman Avenue was relocated to Brower Street by Ozarks Technical College (OTC), and it was razed in 1997. (Courtesy of Ann Woolsey.)

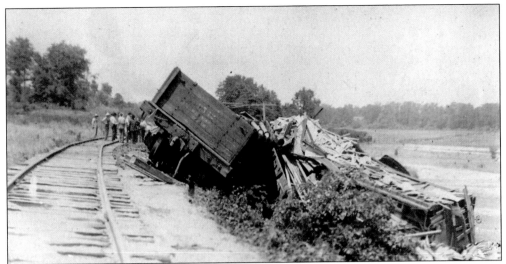

Accidents along the rails were a constant concern. Debris from storms, animals, or even people could end up on the tracks, often too late for the engineer to stop. In May 1886, fourteen-month-old Maud Fulton toddled onto the Gulf Railroad tracks and was decapitated by the locomotive and 25 freight cars. The cause of the 1907 accident pictured is unknown. (Courtesy of First Baptist Church.)

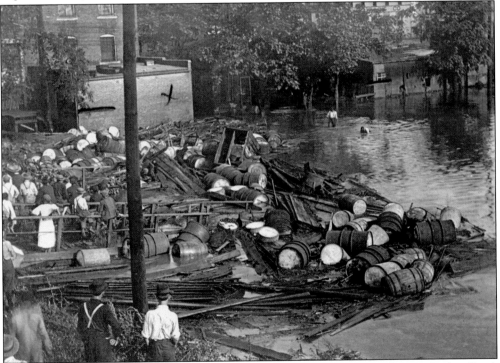

On July 8, 1909, just over 6.5 inches of rain fell in less than 24 hours, overflowing Jordan Creek and destroying homes and businesses. The wooden Pitts M.E. Chapel on North Jefferson Avenue and over 100 horses were swept away. The X marks the back of the Springfield Grocer Company, and the — marks the highest level the water reached. Estimated property damage was over $500,000. (Courtesy of Caroline Post Netzer.)

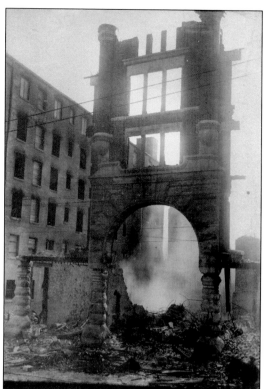

Two men died building the $109,000 Baldwin Theatre on St. Louis Street near Jefferson Avenue in 1892. The builder, Tom Conlon, and Charles Baldwin went broke. While Chief Williamson Canada and Firehouse No. 1 fought the Baldwin Theatre blaze on January 11, 1909, three homes owned by black families burned unheeded due to the inability of the fire department to fight multiple blazes. (Courtesy of Dorothy and Bill McCurdy.)

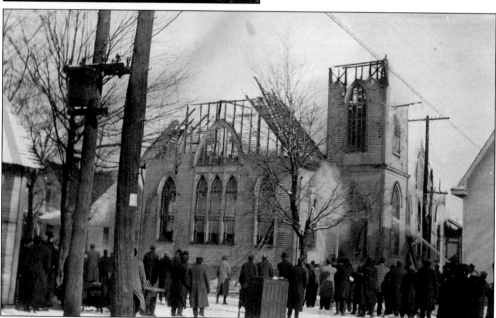

Washington Avenue Baptist Church was built in 1885. The property cost $350 and had one stained-glass window dedicated to Phoebe Tindall, a former slave and long time member. Originally named Second Baptist Church, it was the first African American church built north of Jordan Creek. It was reconstructed following the Thanksgiving morning fire in 1911, which destroyed the roof and severely damaged the interior. (Courtesy of Washington Avenue Baptist Church.)

Springfield hit daily record lows of 12 degrees below zero during the Great Cold Wave of January 1912. The record for the greatest snowfall in 24 hours was set on February 20–21, receiving 20 inches. The storm set the greatest monthly snowfall record with 24.1 inches and the season record for snowfall in 1911–1912 with 54.5 inches. Station No. 2 firemen frolic in the snow on Commercial Street. (Courtesy of Dorothy and Bill McCurdy.)

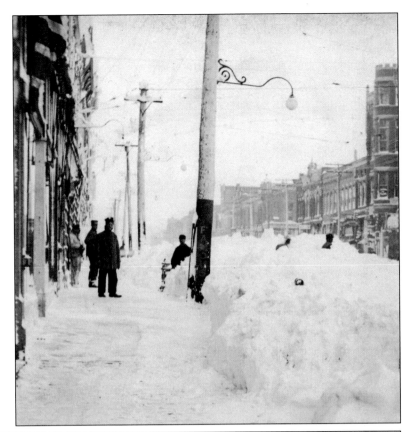

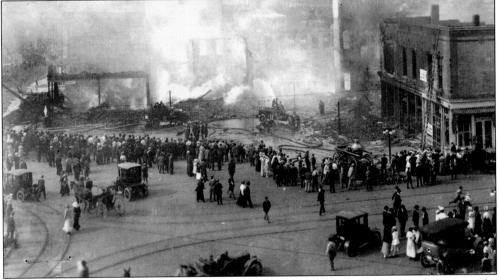

Springfield's worst fire occurred on June 9, 1913, when a fire began in the Heer's Store in the northeast corner of the Public Square. It then spread to Ross Drug Store, Reps Dry Goods Store, King-Martin Realty and Financial Company, Osborne Jewelry Store, Weaver Shoe Store, Queen City Bank, Widbin and Fox Paint Company, and Nathan Clothing Store. The estimated loss was $800,000. (Courtesy of TLC.)

In 1915, there were 821 automobiles in Springfield. Richard O'Neill, nephew of Rose O'Neill, the Kewpie creator, rolled his Buick on Division Street near Summit Avenue in 1916. He may have been exceeding the speed limit of 8 miles per hour inside the city. If he had been outside the city limit, he could have traveled at the whopping rate of 15 miles per hour. (Courtesy of David O'Neill.)

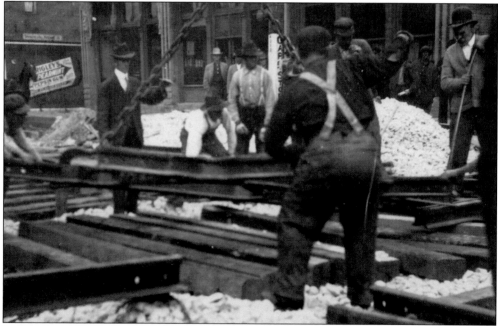

In 1916, Division No. 691 of the Amalgamated Association of Street and Electric Railway Employees were laying track on Boonville Avenue. By October, they were on strike. The Traction Company tried strikebreakers called "scabs" but lost all community support when a scab kidnapped and murdered the J. Holland Keet baby, heir to a $3-million fortune, in May 1917. The 252-day strike ended June 1917. (Courtesy of MSU.)

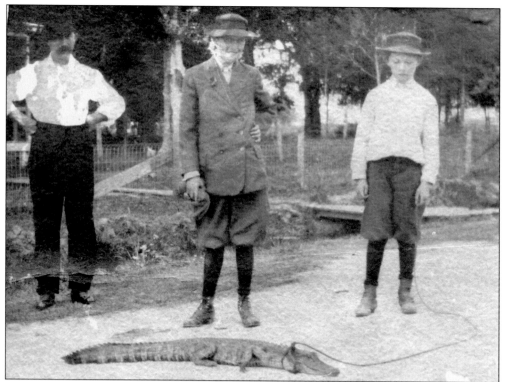

The Morton family had a disaster waiting to happen when they tried walking this alligator. Hopefully, it was heading to the zoo in the Phelps Grove Park neighborhood that opened in 1917. The Phelps Grove Zoo had anteaters, fox, prairie dogs, wolves, ground hogs, doves, swans, ostriches, an American eagle, black bears, bobcats, a lion, and an alligator as part of its exhibit. (Courtesy of Karen Morton Yancey.)

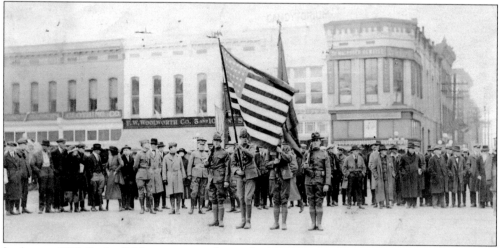

In August 1917, Springfield men mustered into the Missouri National Guard. After two months training at Camp Clark, near Nevada, Missouri, they joined over 14,000 men in a Kansas guard unit. This formed the "Brave 35th Division," former Pres. Harry Truman's unit. They landed in France in May 1918. On November 18, 1918, the Color Guard performed on the Public Square during the Armistice Day celebration. (Courtesy of Jerry Haden.)

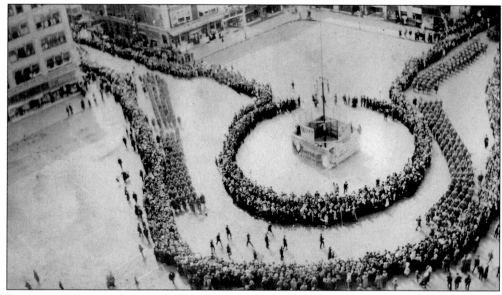

During 1918, two parades were held to celebrate the temporary peace agreement prior to the Treaty of Versailles in 1919. Officials mistakenly held a false Armistice Day celebration on November 7. Then, shortly after midnight on November 11, the news of the real "end of the war" hit the Frisco Station. By 2:30 a.m., the celebration was on and another parade planned. (Courtesy of Midge and Tommy Baker.)

SPRINGFIELD LEA

SPRINGFIELD, MISSOURI. SATURDAY EVENING, AUGUST 6, 1927. —12 PAGES.

RE MAYOR'S HOME

LANDMARK IS DESTROYED BY FIRE

Firemen battled for five hours yesterday when flames of unknown origin destroyed the old Ozarks Hotel building, at Commercial and Benton avenue. The department was handicapped in its work by lack of pressure and the deteriorated condition of the building, but managed to confine the fire. Several narrowly escaped death when a towering cupola crashed without warning to the floor. The picture shows the flames at their height, with the firemen playing several streams of water on the building. A great crowd attracted to the scene.

The South Pacific Railway Company built the Ozark House in 1870 on Commercial Street near the railroad station. It burned in 1874 and was rebuilt in 1879 as the Hotel Ozarks. It later became the Frisco Office Building before the Frisco relocated to Jefferson Avenue and Olive Street. On August 6, 1927, it burned again, and it was finally razed in 1931. (Courtesy of Grace United Methodist Church.)

ORGANIZATIONS

The following archives, records centers, and historical organizations welcome the gifts of books, papers, records, photographs, and other items that would complement their collections. Such materials are carefully preserved while being made available to the public for research purposes. Please consider donating your items to the following:

Drury University
F. W. Olin Library, Special Collections and Archives
900 North Benton Avenue, Springfield MO 65892
Phone: (417) 873-7338 Fax: (417) 873-7432

Evangel University
Klaude Kendrick Library Archives
1111 North Glenstone Avenue, Springfield, MO 65802
Web site: www.evangel.edu Email: shedds@evangel.edu
Phone: (417) 865-2811 Ext. 7357 Fax: (417) 575-5479

Flower Pentecostal Heritage Center
1445 North Boonville Avenue, Springfield, MO 65802
Web site: iFPHC.org Email: Archives@ag.org
Phone: (417) 862-1447 ext. 4400 or (877) 840-5200 (Toll Free) Fax: (417) 862-6203

Greene County Archives and Records Center
1126 Boonville Avenue, Springfield, MO 65802
Web site: www.greenecountymo.org
Phone: (417) 868-4021 Fax: (417) 868-4816

Missouri State University
Duane G. Meyer Library, Special Collections and Archives
901 South National Avenue, Springfield, MO 65897
Website: http://library.missouristate.edu/archives E-mail: Archives@missouristate.edu
Phone: (417) 836-5428 Fax: (417) 836-4764

Railroad Historical Museum, Inc.
1300 North Grant Avenue, Grant Beach Park, Springfield MO 65802
Web site: www.rrhistoricalmuseum.zoomshare.com
Phone: (417) 865-6829 or (417) 883-5319

Springfield–Greene County Library District
The Library Center–The Shepard Room
4653 South Campbell Avenue, Springfield, MO 65810-1723
Web site: http://thelibrary.org/lochist
Phone: (417) 882-0714 Fax: (417) 889-2547

Discover Thousands of Local History Books
Featuring Millions of Vintage Images

Arcadia Publishing, the leading local history publisher in the United States, is committed to making history accessible and meaningful through publishing books that celebrate and preserve the heritage of America's people and places.

Find more books like this at
www.arcadiapublishing.com

Search for your hometown history, your old stomping grounds, and even your favorite sports team.

Consistent with our mission to preserve history on a local level, this book was printed in South Carolina on American-made paper and manufactured entirely in the United States. Products carrying the accredited Forest Stewardship Council (FSC) label are printed on 100 percent FSC-certified paper.

MADE IN THE USA